CW00740766

LEICESTER PUBS

STEPHEN BUTT

AMBERLEY

About the Author

Stephen Butt was formerly a Senior Broadcast Journalist with the BBC. He holds a BA degree in Psychology (Durham) and an MA degree in Regional & Local History (Nottingham). He has published eighteen local history books. He is a parish clerk and is an officer of the Leicestershire Archaeological & Historical Society.

Acknowledgements

Many local historians, landlords and visitors to Leicester's pubs have contributed to this book, their knowledge and guidance was most informative. In particular, I acknowledge the assistance of Steve Tabbernor of the Real Ale Classroom, Billy Allingham from the Steamin' Billy Brewing Company and Brian Rowe for his memories of the Magic Polish Company in Western Road. I have also drawn upon the historical and architectural information within the Conservation Area Reports published by Leicester City Council that are excellent historical overviews in their own right. The photographs of O'Neils and the Fountain pubs are © RNFoster.com.

First published 2016

Amberley Publishing
The Hill, Stroud
Gloucestershire, GL5 4EP

www.amberley-books.com

Copyright © Stephen Butt, 2016
Maps contain Ordnance Survey data.
Crown Copyright and database right, 2016

The right of Stephen Butt to be identified as the Author of this work has been asserted in accordance with the Copyrights, Designs and Patents Act 1988.

ISBN 978 1 4456 5261 0 (print)
ISBN 978 1 4456 5262 7 (ebook)

All rights reserved. No part of this book may be reprinted or reproduced or utilised in any form or by any electronic, mechanical or other means, now known or hereafter invented, including photocopying and recording, or in any information storage or retrieval system, without the permission in writing from the Publishers.

British Library Cataloguing in Publication Data.
A catalogue record for this book is available from the British Library.

Typesetting by Amberley Publishing.
Printed in the UK.

Contents

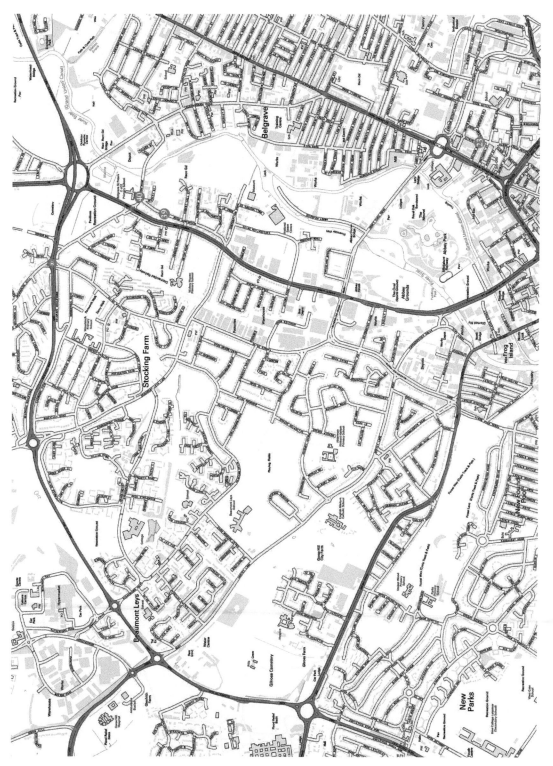

The locations not marked up on map are part of the wider Leicestershire area.

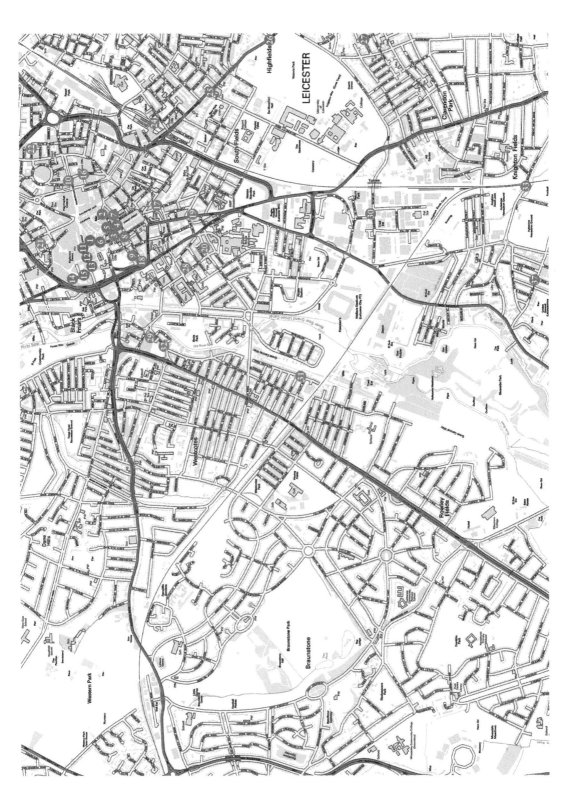

Introduction

The first pubs in Leicester were probably the taverns of the Roman town which served a diverse community. They were houses that were 'public', offering respite from the labours of the day, serving liquid refreshment to a wide range of clientele from distant areas of the Roman Empire. The Romans invented pub signs to indicate that a roadside building was a 'taberna'. In Rome, vine leaves would be hung at the front of the house to indicate that the landlord sold wines. In Britain, where vines were rare, the landlords made do with evergreen leaves.

The earliest recorded Leicester hostelries date to the fourteenth century and were described by their owner's name. Sir John Chandos, knight of the Earl, was entertained in 1310 at Stephen Gifford's tavern. In the following year the same earl's household were feasted by the mayor at the Tavern of Roger of Glen, who represented Leicester in parliament in 1301 and 1302. His household also made use of Henry le Mercer's Tavern, Simon of the Buttery's Tavern near the East Gate, Walter of the Tailor's Tavern, Robert of the Porter's Tavern and those of William of Grantham, John Cook, Walter of Bushby, and William Tubbe, who was mayor in 1363 and who lived in or near the Swinesmarket, the present High Street.

Another Leicester inn often mentioned in the fourteenth century was kept by a Frenchman, Hugh de Lyle from Lille who joined the Leicester Guild Merchant in 1345. His tavern was somewhere in the north of the town, possibly on the old High Street, now Highcross Street.

Later, pubs were places where travellers could stay for the night. Richard III did so at the famous Blue Boar in Highcross Street before the fateful battle of Bosworth Field in 1485. Some local inns served macabre purposes such as the Talbot Inn in Belgrave where condemned prisoners heading to the gallows at nearby Red Hill were granted a final drink.

The Angel Gateway, the small alley that, with Morley Arcade, connects Gallowtree Gate to Cheapside, marks the site of Leicester's most famous inn. A small part of a wooden gable from the old building was visible until recent times. It was trading in 1534 when it was owned by the Guild of Corpus Christi. Many important visitors lodged at The Angel including John Hall, Auditor of the Duchy of Lancaster (1590); the Earl of Huntingdon, and the Earl of Shrewsbury (1597); Princess Elizabeth, eldest daughter of James I (1606); John Frederick, Prince of Wirtenberg (1608); Sir Oliver Cromwell, and 'my lord Cavendishe and his lady who lay at the Angell and dined yesterday at the Abbey with Sir Henry and a sort of gallons that came with them' (1613); Sir William

Herrick and his lady (1622); Prince Charles Louis, son of the Princess Elizabeth of Bohemia, and nephew of Charles I (1636); the Earl of Arundel (1639); and the Earl of Stamford (1642). Tradition holds that Mary Queen of Scots stayed overnight at the inn between prisons.

The high number of inns in Leicester in relation to its size and population in previous centuries may seem surprising. In 1892 there were thirty hostelries in Belgrave Gate, fourteen in Humberstone Gate, twelve in Churchgate and another thirteen in Wharf Street, one of the poorest districts of the town. One obvious reason for this was the town's location on several important coaching routes. Coaching inns, like the motorway service stations of today, provided a range of services for the weary traveller with other relevant trades such as blacksmiths and even hatters, located nearby.

This book is not a gazetteer or a guide to the best pints or the best food in Leicester. This is a snapshot in time of the history and heritage of just a few of Leicester's public houses including the characters, the ghostly residents, the personable landlords and landladies, the folk lore and tall stories and the traditions. There are pubs and taverns, alehouses and hostelries and numerous modern derivatives including gastropubs and good honest 'boozers'. So raise a glass to the past, and should we ever meet in one of these establishments, please feel free to ask 'What's yours?'

Chapter One

The City Centre

1. The Globe, Silver Street

Situated in the heart of the old town, The Globe has been serving food and drink to a colourful mix of clientele since at least 1720. The taste of the original beer, which was brewed on the premises long before the creation of commercial breweries, was no doubt influenced to some extent by the use of spring water drawn from the pub's own well, which still exists today but can only be accessed if several heavy freezers are moved.

Many different activities occurred in this historic building before it became a public house. It served as a market house used at the annual hiring fairs by farmers to recruit their workers for the year, and for some time it provided unwelcomed accommodation for women awaiting impending execution at the gallows south of the town from which the street name Gallowtree Gate derives. This is likely to be the origin of the reported hauntings inside the premises. The ghostly appearances include the figure of a woman on the stairs, two disagreeing brothers who argue at the bar and a young boy in the cellar who has the annoying habit of turning off the beer.

The Globe also played a significant role in the creation of a one-man business which was to grow into Corah, the major name of the nineteenth and twentieth centuries in Leicester's textile industry. It began at The Globe in around 1815 when Nathaniel Corah bought garments from local framework knitters who brought their garments to an upper room at the pub where Corah would buy the best items and transport them to a pub in Birmingham where he would sell them. Corah was from a farming family in Barlestone in Leicestershire who had been trained as a framesmith. From these humble beginnings, and despite spending time in a debtor's prison, he created one of the most important textile companies in England.

One theory as to why this old pub was so named also connects to an aspect of the textile trade when it was a cottage industry, namely the use of glass globes or flasks filled with water which were apparently hung in windows to disperse the available sunlight over a wider area of an otherwise dark room. Globes were certainly used by bobbin lacemakers, but in their case, candles were placed directly behind the globe, which magnified and focussed the light in a similar way to the lens of a lighthouse. Lacemaking involved intricate patterns and used very fine thread. Whether framework knitters required the same amount of illumination is a matter for debate.

A landmark in the old town area for nearly three centuries, The Globe has been owned by the Everards brewery since Victorian times. In 1770, two of the pub's

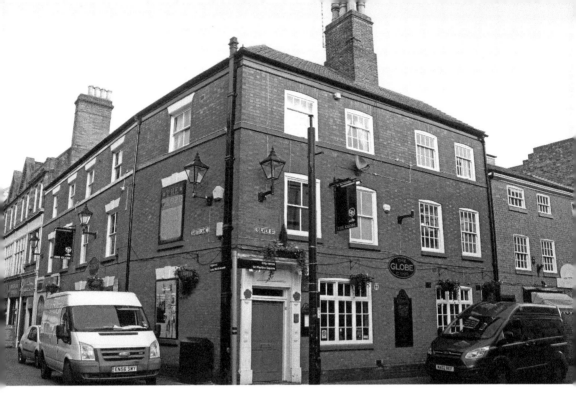

Above: The Globe Inn on Silver Street.

Below: The Globe Inn building has changed little since the early Victorian times.

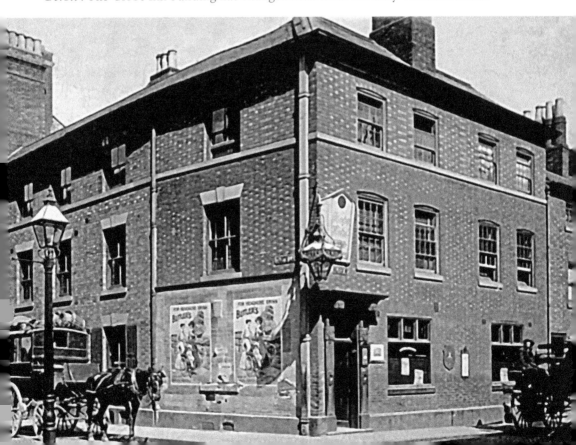

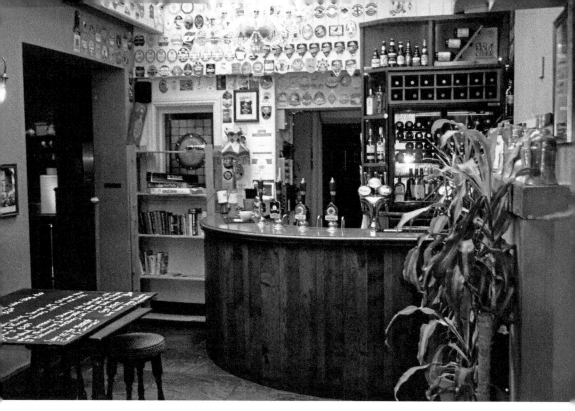

Above: A view of The Globe Inn bar area.

Below: The Globe Inn. The scene of many historic events over almost 300 years.

windows were bricked up to avoid paying the window tax (although this had been introduced as far back as 1696) and these have remained blocked up to the present day.

In the twenty-first century the building finds itself in the heart of the refurbished Leicester Lanes area and near the busy Highcross Shopping Centre. The atmosphere of the past from at least one era of its long history is still present because its bars are lit by gas lamps. This simple but imaginative feature respects this building's remarkable history.

The Leicester branch of CAMRA held its inaugural meeting at The Globe in October 1974, and the pub was awarded their Pub of the Year Award in 1977, being the first Everards house to sell the company's full range of beers on handpumps following a major refurbishment.

2. The Corn Exchange

Between around 1850 and 1880, the character of Leicester's built landscape changed dramatically with the construction of a significant number of iconic buildings which have in time become such familiar landmarks as to be almost invisible to today's shoppers and visitors. Of these, the Corn Exchange in the Market Place stands out as a building of quality and dignity, yet one which for several decades has suffered from neglect at a time when almost all things Victorian were despised. A corn exchange was a building where farmers and merchants traded cereal grains, and they were in English towns and cities until the late nineteenth century.

Leicester's market is not in the centre of the city. The city has seen many markets in its long history which, for a variety of reasons, gradually merged one with the other and ultimately created today's busy Leicester Market which is actually in the far south-east corner of the medieval-walled town.

Until the last century, markets were mainly temporary structures which were erected only on preordained market days, but there have been permanent buildings on the site of the Corn Exchange since the fifteenth century providing accommodation for butchers and clothiers. An earlier building, completed in 1509 and known as the Gainsborough, stood on this site. It was used partly as a gaol and law courts and partly as shops, it also has a dungeon in the cellar. It suffered considerable damage during the Civil War in 1645, but it was not until 1748 that it was replaced by another structure which became known as the Exchange.

Today, this splendid successor to the first Exchange is a busy and welcoming place which, for the first time in its life, is being surrounded by sympathetic modern developments of good quality. Now Grade II listed, it was built by the Leicester architect William Flint, but the upper floor with the impressive external stone staircase was added by F. W. Ordish some years later in 1856. This addition was the result of a competition held by the Corporation, and Ordish's winning design also included the clock tower which gives even more height to the structure. It was well ahead of its time, so much so that many Leicester people instantly disliked it because of the 'shock of the new'. This reaction may explain why, in future decades, the council decided to extend the roofing of the adjacent market in a way that all but concealed the Corn Exchange from view.

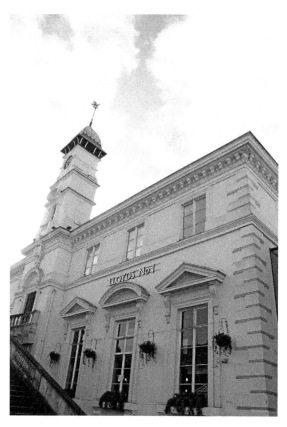

Left: The Corn Exchange in Leicester's Market Place.

Below: The Corn Exchange pictured in 1906 across an empty Market Place.

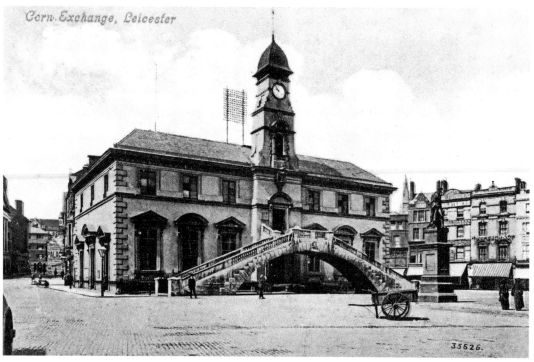

The dance hall on the top floor of the building was once popular with American soldiers and their admirers stationed in the city during the Second World War but fell into disrepair in the 1960s following a serious fire which gutted part of the upper storey.

In recent years, the ground floor has been extensively refurbished in a successful partnership between the pub chain JD Wetherspoon and Leicester City Council. JD Wetherspoon, a company that has become well known for bringing old and sometimes seemingly unsuitable buildings back into life as bars, pubs and hotels, operates the Corn Exchange under their Lloyds No. 1 brand.

The city council still owns the building, and this has provided the authority with an opportunity to include it in a far-reaching twenty-first-century development of the entire market area. This has seen, in 2015, the first stage of the new indoor market costing over £4 million. Designed by architects Grieg & Stephenson, it is lightly connected to the Corn Exchange by a glazed roof. The second stage, approved in 2015 with a budget of over £9 million involved the demolition of the old indoor market building which will be replaced by an extension to include a bar and restaurant area giving access to the old ballroom on the upper floor of the Exchange.

3. The Friary, Hotel Street

The remarkable discovery of the remains of Richard III in Greyfriars in 2012 and the consequent reinterment at Leicester Cathedral in 2015 has changed Leicester in many

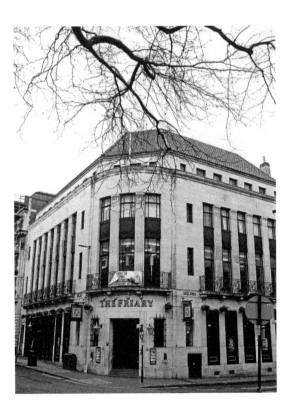

The Friary, Hotel Street in a building designed as offices.

ways. The events which were televised worldwide have certainly reinvigorated that part of the city, bringing new life and new uses to many otherwise redundant buildings.

The Friary is an example, describing itself as 'a traditional pub' despite having opened only a few years ago. Clearly, The Friary wants to connect with the booming tourism trade by saying that it is 'located just around the corner from the King Richard III Visitor Centre and Leicester Cathedral'. Standing on the corner of Hotel Street and Market Place South, the building, designed as offices, is indeed close to the site of the former friary, being on the south-east corner of the friary precinct.

Hotel Street actually refers to the building that is now the City Rooms and stands opposite the Friary. It was built in 1792 as a hotel but never functioned in its intended role. It is one of the few buildings (together with the old Elizabethan Grammar School in Highcross Street) included by the antiquarian historian John Nichols in his monumental *History and Antiquities of the County of Leicester* (1815) where you can still enjoy food and drink today.

4. Molly O'Grady, Hotel Street

Members of the Irish community and those who have a fondness for the Emerald Isle certainly feel at home in this characterful pub tucked away behind Leicester Market on the corner of Hotel Street and Market Street; but the rather enforced 'Irishness' masks a long and fascinating history, which links the ancient market place to Leicester Abbey and even to men who fought alongside Lord Nelson at the Battle of Trafalgar.

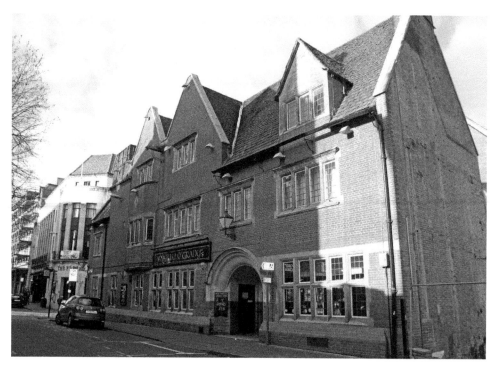

The Irish-themed Molly O'Grady, formerly the ancient Saracen's Head.

Nearly 700 years ago, this hostelry was called the Saracen's Head. It was already over 150 years old when Richard III stayed in the town on the night before the Battle of Bosworth Field. Documentary sources confirm that it was granted to Leicester Abbey by William de Langley in 1312, which suggests that it was already in existence by that date.

By the eighteenth century, the inn housed the town's rat pit and was known for cockfights. It was also used as a recruiting point for the Royal Navy so it is likely that some of the Leicester men who fought with Nelson at Trafalgar had joined up within the Saracen Head's ancient walls.

The old inn, which may itself have replaced an even earlier structure, was demolished in the early years of the twentieth century. Contemporary accounts described it as having 'cosy rooms and centuries-old beams and panelling'. It was replaced by the building that still stands today, designed by the Leicester architect Stockdale Harrison, whose son designed and built the De Montfort Hall less than ten years later. The architectural style is certainly distinctive, including a large roof of Swithland slate. At the time it was seen as the best new pub in Leicester, and boasted 'extensive neon lighting' installed by Tarratt & Brothers Ltd of Leicester. A booklet produced by Everards brewery at the time commented:

> You cannot miss the Saracen's Head, even at night time. Blackpool illuminations are not more artistically arranged or more effectively impressive than the extensive neon lighting of this well-known and old-established inn, constructed and carried out in every alluring detail by the well-known and highly qualified firm of Messrs Tarratt Bros Ltd, Electrical Engineers, of Leicester.
>
> It is indeed a high tribute to their electrical engineering skill and wonderful ability for appealing effect. It can be seen from the Market Place and every street corner within the orbit of its brilliant light and the greatest credit is due to Tarratt Bros for the success they have achieved, and it stands as a beacon of friendly welcome outside the house, extending a warm invitation to enjoy the hospitality and cosy comfort to be found within.

Some artefacts from the earlier building were incorporated into the new construction, including the fireplace which is said to date to the sixteenth century. Unsurprisingly, it is claimed that the pub is haunted. Various groups have investigated the claims of mysterious lights and shadows, doors being slammed and guests being touched, but the only material evidence for spirits appear to be those behind the bar. Many of the older buildings that surround the market place began as market stalls, temporary at first, but gradually becoming more permanent structures as the wealthier merchants established their presence.

As for Molly O'Grady's history, she never really existed as a real person. Her only incarnation was as a peasant girl in *The Emerald Isle*, or *The Caves of Carrig-Cleena*, a comic opera in two acts with music by Sir Arthur Sullivan and Edward German, which was first performed at The Savoy theatre in London in 1901.

5. The Market Tavern

All is not what it seems at the Market Tavern in the Market Place. At first sight it looks traditional with more than a hint of the medieval, and the cobbled lane outside adds to the illusion. It is located between the lane called Market Place and what is referred to locally as the Jetty or Jitty, being a narrow lane leading from Hotel Street into the market area. It feels old, and it occupies a Grade II listed building. Indeed, the structure of the building dates to the later decades of the 1700s, and in the 1880s one Frederick Page is recorded as being a 'wine merchant' at this address, but the pub as it stands today is actually the most recent business in a long history of changes and reincarnations.

Depending on one's age, it is the Jetty or Jitty, or the Paget, or the Fountain, or the Cork & Bottle or Corkers – or Yates Wine Lodge. It has also been home to a china and glass business, and the old Midland Educational Co. Yates acquired the premises in 1986, and it first became the Market Tavern in 2005 – but only for two years. It reopened yet again in 2007 with the same name and then spent a short time trading as Alfie's Fun Bar, finally to be refurbished and reappearing in its present form in 2009. In 2016 it was surrounded in scaffolding for yet another facelift.

Today it is still the Market Tavern, a busy city centre pub that connects perfectly in its style and branding with the nearby market. The Jetty refers to the narrow cobbled path which links Hotel Street with the Market Place. There is a further history behind the name which may derive from a French word for a passage where the buildings on either side overhang. This could of course describe any number of lanes and streets in medieval Leicester.

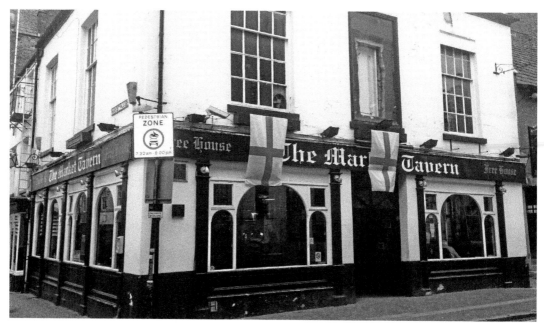

The Market Tavern, an old pub in its latest incarnation.

Evidence of the Market Tavern's early structure viewed from the Jetty.

Architecturally, the most important element of the building is at the back, which is mainly eighteenth century, except for the profusion of wheelie bins.

6. O'Neills, Loseby Lane

A Leicester tradition which is held on the Feast of St John the Baptist, rather than on St Patrick's Day, takes place each year at O'Neills Irish Pub in Loseby Lane. The Lord Mayor of Leicester accompanied by members of the Gild of Freemen of the City of Leicester, collect a damask rose as the annual peppercorn rent.

Elements of this quaint ceremony date to medieval times as in the choice of a red rose, the emblem of the House of Lancaster. The pub stands on or near a garden or parcel of land which was formerly in the ownership of the Honour of Lancaster. Some historians suggest that it was the site of a hostel which belonged to the College of St Mary of the Annunciation in the Newarke, established in 1361. The church within the college was built as a mausoleum for members of the House of Lancaster, hence the choice of a deep-red rose, it being the emblem of Lancaster.

After the Reformation the college was closed at Easter in 1548 and its land and holdings sold off. On 24 February 1636, the land in Loseby Lane, adjacent to his own property, was purchased from the Duchy of Lancaster by a local shoemaker, James Teale and his wife Elizabeth, for the sum of £2 on condition that he also paid a peppercorn ground rent amounting to 4p and a deep red damask rose on 24 June each year, the feast day of St John the Baptist.

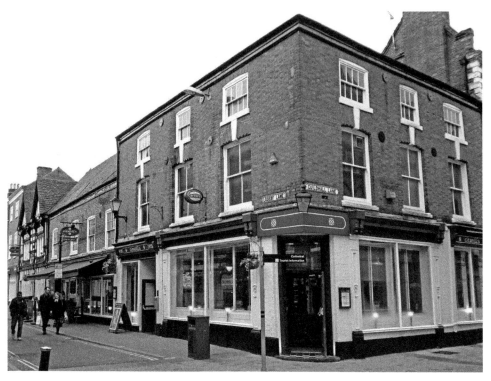

O'Neills, for many years, the Crown & Thistle (courtesy rnfoster.com).

The actual record of the contract which still exists says:

> To beholden of our said sovereign lord the King his heirs and successors as of his honor of Leicester in the right of his Highness, Duchy of Lancaster by fealtye only in common soccage and not in Capital: Yielding and paying therefore yearly unto the mayor of the Borough of Leicester for the time being one Damask rose at or upon the feast day of Saint John the Baptist.

Sometime in the decades that followed, the site became a public house. By 1729, it is noted in the Records of the Borough of Leicester as the Red Cow, the landlord being Samuel Coates. In an entry for 1771, the payment was recorded as being made by 'the heirs of Executors of Samuel Coates' for a house later called the Star & Ball and now the Crown & Thistle, late the land of Jackson in the occupation of Alexander Forrester. The date is given as Midsummer, also St John's Day, one of England's quarter days when rents were due.

The tradition continued through to the end of the twentieth century while Ind Coope owned the pub and when the rent was collected by the city treasurer, but then fell into abeyance until 2010 when the lord mayor at that time, Councillor Colin Hall, restored the tradition, with the enthusiastic co-operation of O'Neills' management, by calling to collect the rent in his formal robes and chain of office. A plaque has now been installed on the premises explaining the ancient custom to visitors from outside the area.

There are other fascinating stories about this building, including a claim that a tunnel exists which connected the pub's cellars to the cathedral, and that it served as an overnight resting place for Lady Jane Grey.

The association of the red rose with the House of Lancaster dates to Edmund Crouchback (1245–1296) the second son of Henry III and Earl of Lancaster whose second marriage was to Blanche of Artois, a granddaughter of Louis VIII, king of France. With this marriage Edmund assumed the title of Count Palatine of Champagne and Brie. Through this connection with Champagne, and the district of Provins, Edmund adopted the damask rose (of Provins) as his personal emblem.

The Lancaster rose appears on many hundreds of pub signs across England in the form of the 'Rose and Crown'. This commemorates the union of the Houses of Lancaster and York with the marriage of Henry VII to Elizabeth of York in 1486, following his victory over Richard III at the Battle of Bosworth. The marriage ended the Wars of the Roses.

Loseby Lane is in itself one of the gems of Leicester's old town streets, packed with attractive independent shops, bars and cafes with a street culture all of its own, yet only minutes away from the modern sophistication of the Highcross Centre. Despite its long and well-documented history, no one can explain the reason why, in 1996, the entire frontage of the building facing Guildhall Lane was painted bright blue.

The buildings connected with and adjacent to O'Neills also have a fascinating heritage. Mainly they date from the middle of the eighteenth century and so have a long and rich history. The oldest of the group of former residential properties is No. 10 Guildhall Lane. In the 1830s this building was used as overflow cells if the nearby police cells at the Guildhall were fully occupied. Just before the turn of the twentieth century it became the Opera House Hotel but was closed down in 1914 having gained a reputation for being a house of ill repute. After having been occupied by various businesses included a sewing machine manufacturer and an antiques retailer, the building reopened once again as the Opera House restaurant, then as the Epernay Champagne Bar and is presently trading as Taps. A spiral wrought-iron staircase provides access for customers to the cellar area.

7. Firebug, No. 1 Millstone Lane

The Firebug was formerly called Firefly! and before 2006 it was the more Victorian sounding Lamplighter, which was probably the most appropriate name for this building. All three names are connected to the business that was previously conducted here and for which these Victorian premises were constructed in 1864 to a design by local architect Edward Burgess this being the Corporation Gas Department offices. The words 'Gas Offices' can still be seen in the sandstone canopy above the former entrance facing Horsefair Street.

Local corporation gas enterprises in this area were replaced by East Midlands Gas in 1948 when British gas production and distribution was nationalised by Clement Atlee's Labour government. The regional gas boards were in turn merged into British Gas in 1972, which was then privatised in 1986. Following further restructuring, the company stopped selling gas appliances, and the premises, which occupied a prominent

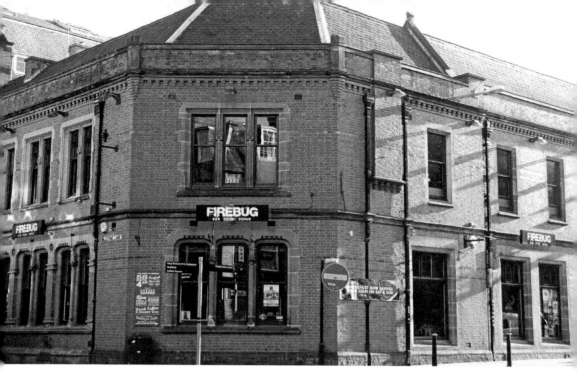

The Firebug occupying Leicester's former Gas Board offices.

corner location in the centre of Leicester's retail quarter were put up for sale in 1987 and converted into licensed premises. The gas showroom, where the latest appliances could be purchased and domestic science advisers were on hand to show customers how best to cook with gas, was nearby in Market Street.

Firebug is a clever name for a pub that occupies former gas offices. Not only is it reminiscent of the long-established Glow-worm brand of gas boilers, but it is the name of the insect which glows in the dark, and for those of a certain age, of three fiendish villains created by DC Comics as Batman's adversaries in Gotham City. Two further villains of the same genre were also named Firefly. More recently, IT specialists will know it as the name of computer software used for detecting technical issues on many websites.

8. The Rutland & Derby, Nos 19–23 Millstone Lane

The Rutland & Derby boasts a dignified exterior enhancing the visual perspective of a street that has enjoyed considerable regeneration in recent years and is now integrated into the Market Street and Greyfriars Conservation Area. Built in the mid-nineteenth century, the pub expanded to replace and combine two Victorian workshops sometime in the 1930s, and was originally known simply as The Derby.

In the past it was described by locals as 'likeable, but rough and ready,' but the arrival of a forward-thinking landlord in 2012 helped to take this pub into the modern world. Its marketing now emphasises its proximity to Leicester Cathedral, the Richard III Visitor Centre and the Curve Theatre, clearly indicating the clientele it would like to be serving as a 'focused purveyor of quality craft beers, lagers and spirits as well as original wines

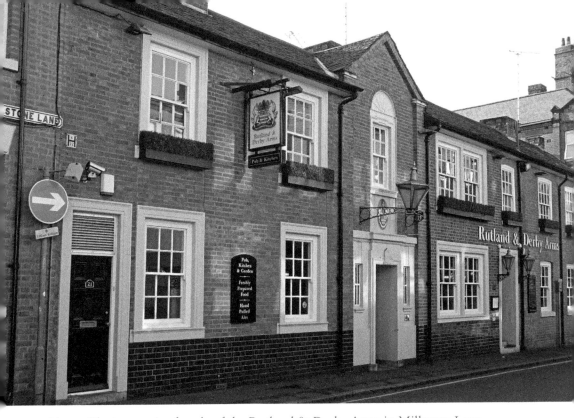

Above: The impressive façade of the Rutland & Derby Arms in Millstone Lane.

Below: An Everard's steam dray lorry as used by breweries until the 1930s.

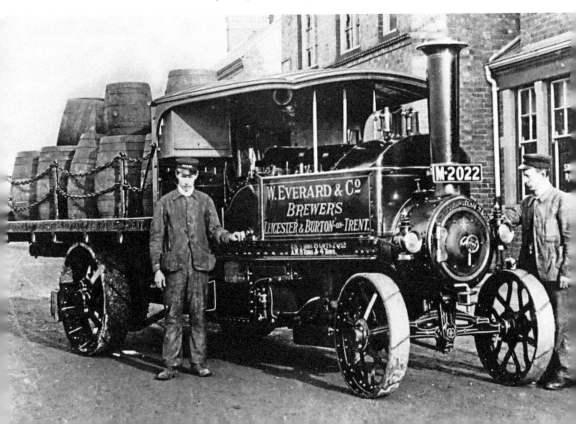

and hand-crafted cocktails'. The Rutland & Derby has been awarded Best Independent Pub in 2011, 2012 and 2013 at the Annual Leicester Best Bar None Awards.

In 2013, the then landlord Sam Hagger launched a Bring Back Jugs campaign having purchased hundreds of the traditional dimpled-style jugs with glass handles. Regular customers are given the opportunity to have their names individually engraved on their dimpled glass. Hagger wanted his customers to feel part of a pub 'community' and believed that the reintroduction of the dimpled jugs would help to achieve that aim. Speaking to the *Leicester Mercury*, he explained that the dimpled jugs used to be synonymous with a traditional thriving pub atmosphere and were an essential part of the whole pub experience:

> I feel that the jugs gave people a sense of ownership and belonging to a pub and that's something I want to see return. Customers can come in and order a pint in their own personalised jug and immediately feel warm and welcomed in that environment.
>
> We plan to get as many people as possible with their own jugs and it would be great to see other pubs in Leicester offer a similar thing to their regulars.

9. The Criterion Free House, Millstone Lane

The Criterion of today replaced the very ancient Nag's Head which was located on Southgates, the extension of Highcross Street, and is actually located at the end

The Criterion, now a focus for music and comedy, replaced the ancient Nag's Head.

of Millstone Lane. It is conveniently placed to serve customers from both the legal quarter of the old town and the students of De Montfort University, although today the students far outnumber the solicitors.

It has to be said that the architecture leaves much to be desired, especially as it is in the shadow of such historic edifices as the Newarke or Magazine Gateway (built *c.* 1410) and at the end of a street that has many dignified façades, but the profusion of plastic flowers in tubs along the first-floor window line enhance the vista to some extent. The building dates to the late 1960s which was not Leicester's finest era for new building design.

Before Leicester's Central Ring was bulldozed through the heart of the oldest part of the city, Millstone Lane marked the line of the old town wall to the south, and would have been far more connected with the Newarke and the South Gate. Hence, from a vantage point very close to the location of the Criterion today, observers might have seen the body of the slain Richard III being carried out of the Newarke Gateway (where it had lain in state in the Church of St Mary of the Annunciation for three days) through the South Gate and on towards the Grey Friary. More than five centuries later, the Criterion and the remainder of Millstone Lane stands isolated from its former history.

10. The Fountain, No. 52 Humberstone Gate

In a modern city and at a time when pubs have to provide for a wide range of tastes and expectations, there is still room for an establishment that is traditional. The Fountain is certainly an old style pub, unpretentious, modest and without a theme. Despite

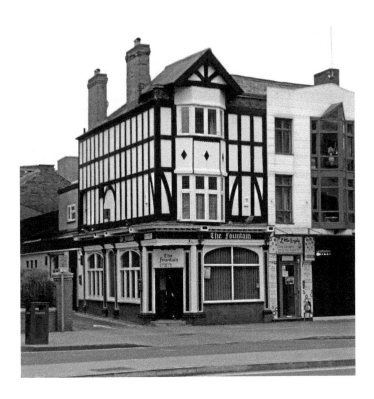

The Fountain in Humberstone Gate, which has been trading since the 1880s (courtesy rnfoster.com).

the somewhat overpowering mock-Tudor timber on both its exterior walls, it is a typical street-corner Victorian building which although smart and attractive still has an atmosphere which echoes the past. In Victorian times, a notorious fair was held in Humberstone Gate. Mary Jane Merrick, the mother of Joseph Merrick, who is familiarly known as the 'Elephant Man', always believed that her son's deformities were due to her being frightened by performing elephants at the Humberstone Fair when she was pregnant.

It stands on the corner of Humberstone Gate and Hill Street, the narrow lane that runs between the pub and the former Wyggeston Girl's School towards Lee Circle and the Wharf Street area. The school was built in 1878, and the Fountain was trading by 1881 and was probably open some years before then. The school building is now the Leicester city headquarters of Age UK, Leicestershire and Rutland, and was renamed Clarence House when it was acquired.

From 1944 to 1966 the school was occupied by the City of Leicester Boy's School whose alumni include retired footballer and current sports broadcaster Gary Lineker, *Foyle's War* actor Michael Kitchen, and political aide and broadcaster Alastair Campbell. One wonders if, at some time in the past, these gentlemen and others of distinction have savoured a nostalgic pint in the Fountain.

11. The Queen of Bradgate, High Street

Many pubs claim to offer some added value to their basic function of dispensing alcoholic refreshment accompanied, usually, by some food. The Queen of Bradgate can certainly claim to provide something very different. It also sells furniture and doubles as a soft furnishings showroom.

The pub takes its name from the unfortunate Lady Jane Grey. Traditionally it was thought that she was born at her family home at Bradgate in Leicestershire but modern

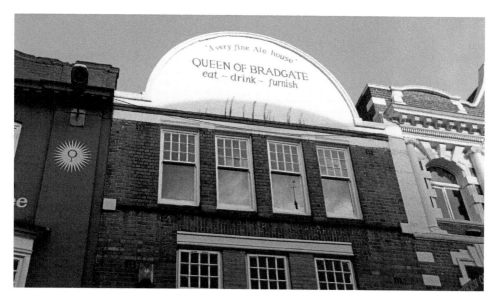

The Queen of Bradgate, one of several large High Street pubs.

Right: The Queen of Bradgate –
interior design combined with food
and drink.

Below: There is no difficulty in 'calling
time' at the Queen of Bradgate.

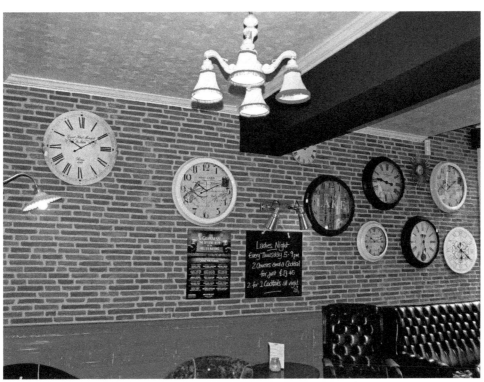

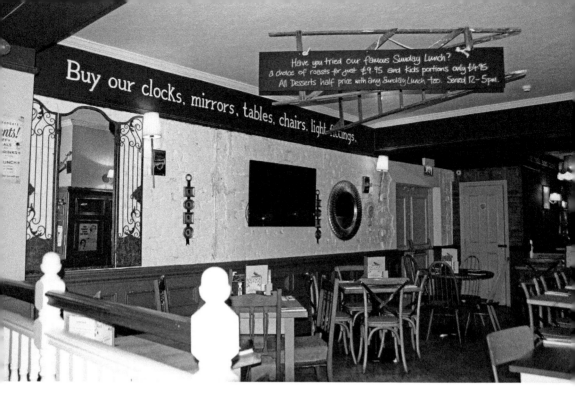

The Queen of Bradgate – possibly the only Leicester pub where you can leave with the furniture!

research suggests she was born in London in 1536 or 1537. She was Queen of England for just nine days, at the age of sixteen or seventeen years, and was later executed for high treason. She is the only English monarch in the last 500 years of whom no proven contemporary portrait survives.

Having been empty for some years, the refurbishment of the building cost £200,000. In its former life, the pub had a reputation possibly described as a 'spit and sawdust' establishment, which may have lingered until local people discovered that it was very much a new and forward-thinking enterprise. It now employs some twenty staff and combines providing real ales and cask beers with off-the-shelf, recycled and bespoke furniture and furnishings. In the words of its owner, Matt Saunders, he has created 'a sort of living, breathing showroom for an online, British made (in the main part, Midlands made) bespoke, upcycled furnishings and interiors business called Queen B. Interiors'.

Curiously, for twenty years, the old pub did serve as a shop retailing furniture. It is almost certainly the only pub in Leicester where, if you wanted to, you could walk out with the table you have just been sitting at, having enjoyed artisan food prepared from locally sourced produce.

12. The Orange Tree, High Street

This pub traded for almost a century since it was built in 1902 as the Haunch of Venison and is one of four public houses together, situated at the west end of the High Street. Until the construction of the Shires Shopping precinct, later extended into

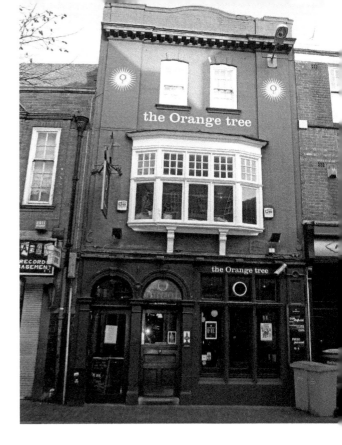

The Orange Tree in Leicester's busy High Street.

the Highcross Centre, this part of the High Street was remote from the main retail shopping area and somewhat run-down. In 1997, the pub was reopened as the first part of what became a developing business.

Now, in 2015 the Orange Tree group owns and runs six pubs in Leicester and Nottingham including two pubs of the same name to their Leicester acquisition in Loughborough and Nottingham.

The orange tree is a powerful symbol: it signifies wisdom, generosity, chastity and purity. In the Middle Ages, brides traditionally wore orange tree flowers in their hair; but in some literature, the orange tree takes the place of the tree of knowledge as presented in the creation story in the Old Testament and elsewhere and so it could also represent the decline and sinful fall of mankind. This would certainly be the interpretation placed upon such a pub name if it existed in the heyday of the nineteenth-century Temperance movement led locally by men such as Thomas Cook.

13. The Highcross, Nos 103–105 High Street

An impressive building at the very heart of Leicester, this JD Wetherspoon house is a busy and popular venue, especially for those who enjoy an evening drink or two before moving on to the nearby night clubs. The Wetherspoons chain was launched in 1979 and its success has been due largely to its strong national branding which means that the Highcross provides exactly what a Wetherspoons customer expects – inexpensive drinks and a menu that is the same at every one of its pubs across the country.

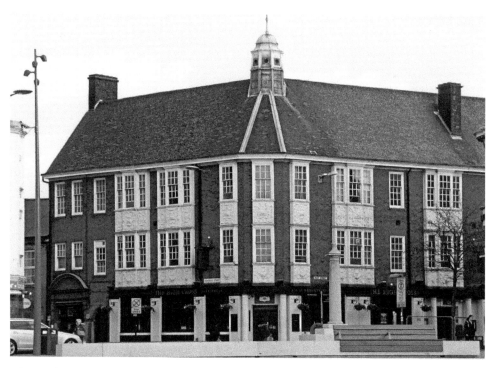

The Highcross stands at the important junction of High Street and Highcross Street.

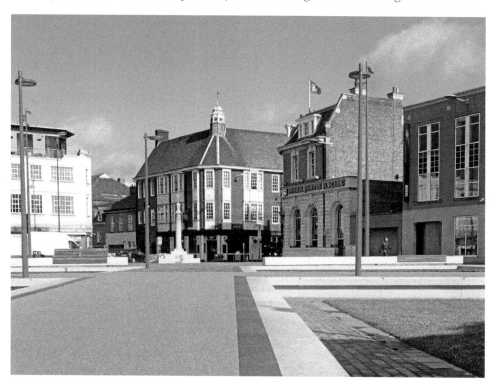

The Highcross, viewed across the modern Jubilee Square.

The medieval high cross stood here
from at least the thirteenth century.

Historically, it can be said with some assurance that there has been an establishment selling alcoholic drink very near to this site since Roman times. The centre of the Roman town was here, with the forum and baths nearby. Later, it became Leicester's bustling market place. The actual high cross, marking the centre of the town and the convergence of the streets leading from the four entrances to the town, was erected right outside where the pub now stands. Records indicate that the cross was repaired in 1278, suggesting that by that time it was already an old structure. Alderman Gabriel Newton, who founded the school which has borne his name, was the landlord of the Horse & Trumpet, a large public house which stood close by. It is said that its sign board hung across the street and was attached to the actual high cross. Whether the Horse & Trumpet stood on part of the site occupied now by the Highcross is a matter of debate but it is very likely that the old and present pubs shared the same footprint.

The present building was constructed in the 1880s and was designed by local architect Edward Burgess, one of Leicester's finest architects. He also designed the former Gas Offices at Nos 8–10 Millstone Lane, which is now a pub, and the former Wyggeston Girls School on Humberstone Gate, next to the Fountain, now the local headquarters of Age UK.

He built the high cross for the Leicester Coffee & Cocoa House Co. Ltd and it was later a branch of Barclays Bank as well as a local office for the Commercial Union Insurance Company. Wetherspoons acquired the building in 1998 when it was then a shop selling domestic lighting.

14. The Cosy Club, Nos 62–68 Highcross Street

It is perhaps surprising that a conversion which makes use of a redundant building from Leicester's textile manufacturing past is a rarity, given the extent of that industry in its heyday and the number of buildings that remain empty today, awaiting either a new use or demolition.

The Cosy Club in Leicester opened in October 2014 in the former knitwear factory of Veejay Knitwear, the successor to several previous small-scale textile manufacturers who occupied the premises including Humphries & Sons Ltd in the 1950s. This late Victorian building has therefore been used for the manufacture of boots, shoes, hats, clothes and hosiery products. The transformation of the building from factory to restaurant bar cost over £600,000, and attention was paid to retaining the original industrial heritage of the site.

The interior of this all-day bar and restaurant now includes coloured cotton and spinning wheels within the bar, historic building dates displayed on the windows and some original local textile pieces on the walls. It has refurbished the high windows, factory lighting, bare steel riveted girders and original stone walls. There is a 'secret' garden, and a further room for private hire in the basement known as the Loom Room.

The building is opposite the entrance to the Highcross Shopping Centre car park and the site of the former Borough Gaol. Leicester artist John Flower (1793–1861) provided a detailed engraving of this location as seen from the junction with the High Street looking north to where the Cosy Club stands today.

The Cosy Club chain was established four years ago as part of the Loungers brand which was established in 2002. One of its directors is Alex Reilley, who previously worked at The Case in Leicester as a waiter and was later a trainee manager. The other directors are Jake Bishop and Nick Collins. The company's turnover is more than £35 million.

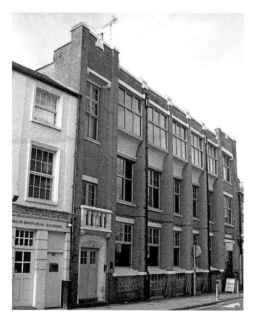

The Cosy Club, in a former knitwear factory, opposite the Highcross Centre.

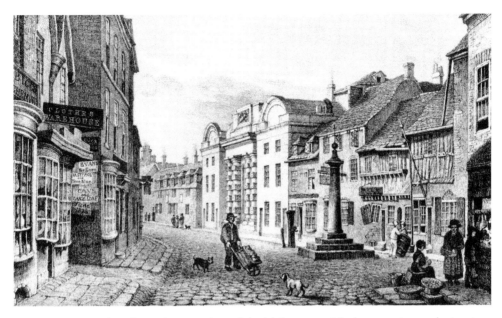

Leicester artist John Flower's engraving of the high cross with three ancient pubs in view.

15. King Richard III, Highcross Street

Many of the tourists who have flocked to Leicester since the discovery of the remains of Richard III beneath a council car park in the Greyfriars area will have noticed – and probably been to – this modest pub in Highcross Street. It is an Everards pub, and provides an appealing understated retreat away from the noisier and busier inns of the city centre.

Once the bustling high street of the old town, Highcross Street was a backwater for many years, but although it is still lacking an identity, the development of the Highcross Shopping Centre has led to the refurbishment of many of the properties nearest the junction with the present High Street and the new Jubilee Square.

Of course, this is not a pub that has a direct association with the monarch whose name it bears, except in its proximity to the site of the famous White Boar Inn, later renamed the Blue Boar, where King Richard spent the night before the Battle of Bosworth Field in 1485. That old hostelry was further along the street. A Travelodge and casino stand on the site today. The Blue Boar was demolished in 1836 and a new inn with the same name was constructed shortly afterwards some 300 yards south in Southgate Street, also owned for some years by Everards. That too has now disappeared, having been demolished in 1972, but the Richard III has survived with a history of serving ales since the late nineteenth century.

To mark the reinternment, Everards created a Blue Boar Honey and Mead Ale, and the Richard III, seeing an opportunity to make the most of their name, held a number of traditional events including a twelve-hour game-a-thon with pub games claimed to have been similar to those played in Richard III's day, including quoits in the garden, a card game called Niddy Noddy, draughts, and a dice game called Glückhaus which has its roots in late medieval Germany.

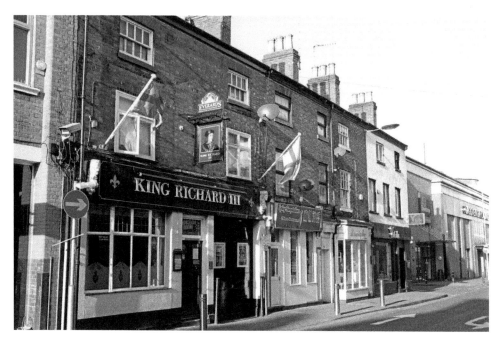

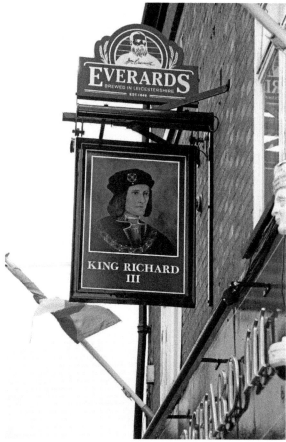

Above: The present King Richard III pub in Highcross Street.

Left: Richard III passed this way in 1485 though this pub is a much later building.

Chapter Two

One Step Further

16. The Exchange, Cultural Quarter, Rutland Street

Grade II listed, the Exchange Buildings were once home to the Leicester Auctioneers & Estate Agents Association, the National Federation of Shopkeepers and the Midlands Area Coach & Transport Association. The buildings became outdated and failed to meet modern expectations in office facilities, but they have been given a new life as an integral part of the St George's Conservation Area and Leicester's Cultural Quarter. This has brought new prosperity to the neighbourhood and new life to these significant Leicester buildings.

They were designed as offices by the Leicester architects Stockdale Harrison in 1888. As with so many designs by this family company, many exciting, even fun ideas were

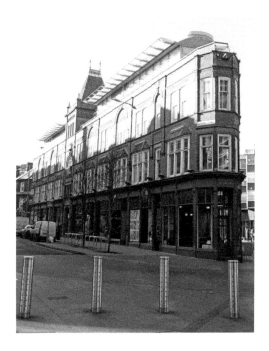

The 'flat iron' design of the Exchange building predates New York's more famous example.

integrated into an otherwise ordinary Victorian office block, making great use, for instance, of the narrow corner at the junction of Wigston Street and Rutland Street, the French Pavilion roof and the dramatic flat iron end at Halford Street providing a double vista into Charles Street (which of course was constructed much later). This building also has an almost intact set of original shopfronts. The building actually predates the famous Flatiron Building in Manhattan, New York, which opened in June 1902.

Into this once redundant building comes a new and confident business enterprise, the refurbishment shrewdly judged to appeal to the theatre-going clientele, the young entrepreneurs who are based at the Phoenix Cinema & Art Centre, the LCB Depot, and to visitors alike. Breakfast is served from 9.00 a.m. from £1 per serving. There is even a 'bumps, babies and toddler' group which meets every Friday in the cellar, with soft blankets, cushions and toys, and spaces for books and toys. Space is reserved at street level for pushchairs, and changing facilities are provided too.

17. King's Head, King Street (aka The Kings)

Dating to the earlier decades of the nineteenth century, when this street and others in the area were laid out, in recent years, the King's Head, housed in a sedate and beautifully balanced Georgian building, has become very popular with real ale drinkers and has gained many accolades for the quality of its beers.

One assumes that the pub's name refers to a monarch of the House of Hanover as George III died in 1820, but nearby are Prince Street, Duke Street and Marquis Street as well as Regent Road so perhaps another theme like royalty underlies the area.

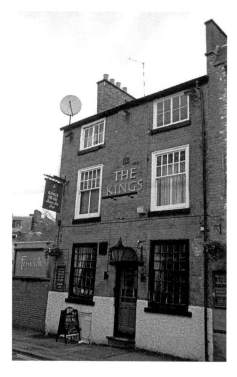

The King's Head, a dignified and unpretentious Georgian pub.

It is said that the steam whistle, as attached to steam railway locomotives, was developed somewhere near to King Street. The story suggests that following an accident on his Leicester–Swannington line in the 1840s when one of his trains hit a horse-drawn cart on the way to Leicester market at a point where the railway crossed a road, Robert Stephenson decided that his engines needed an audible means of approach, and that he sought the services of a church organ builder in Duke Street. However, it has to be noted that a search of street directories covering that period has failed to reveal any such business in the vicinity of the King's Head.

This city centre public house was the first acquisition in the East Midlands by Black Country Ales, and was winner of the Leicester CAMRA Pub of the Year Award in 2015. This microbrewery is based in Dudley in the West Midlands, and continues a brewing tradition that started on the site in the 1830s by a butcher, Edward Guest, as a side line for his local customers. The Guest family brewed for many years before passing the business on to Eli Bradley in 1870. The Bradleys carried on the tradition of producing hand-crafted real ales of quality for six generations but this finally ceased just after the Second World War when the brewery was mothballed. Brewing recommenced in 2003.

18. The (Princess) Charlotte, Oxford Street

Despite limitations of space, the legendary Charlotte was one of Leicester's top live music venues for many years, especially in the 1990s under the management of Andy Wright who took over the pub in March 1989 having worked there for the previous

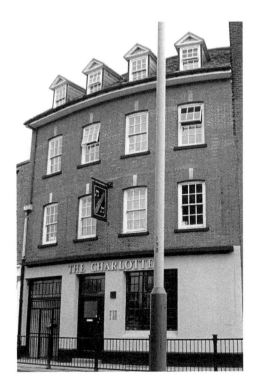

Once Leicester's foremost live music pub, the legendary Charlotte.

four years. Under his tenure numerous big names played in the small back room which accommodated a maximum of 200 people here including Blur, Pulp, Coldplay, Arctic Monkeys, Radiohead, Primal Scream, Carter USM, Elastica, the Cranberries, the Stone Roses, the La's, Spiritualized, the Killers, Bloc Party, the Blow Monkeys, Brian and the Teenagers, Kingmaker, Oasis, the Offspring, Razorlight, the Buzzcocks, the Libertines, Muse and Leicester's own Kasabian.

Blur included footage of one of their appearances at the Charlotte in their fly-on-the-wall documentary film *Starshaped*, released in 1994 and re-released as a DVD in 2004. Four numbers are included from sets recorded here in Leicester, 'Won't Do It', 'There's No Other Way', 'High Cool' and 'Wear Me Down'.

The Charlotte was an important and popular venue on the 'toilet circuit', a group of small independent music pubs across the country whose generic name derived from the fact that one of their venues, the Tunbridge Wells Forum, had been converted from a public convenience. Even in its earliest days as a music venue, the bands at the Charlotte were never forced into that predicament, but they certainly used to play in the back yard until rain stopped play. In later years, the yard was covered over making for a more convenient and performance area.

However, despite its fame the original Charlotte struggled to secure the big names as costs rose to match the progress of inflation. When Oasis first played at the venue in 1993, they were paid £50, the going rate for a gig at the time. It is claimed that the word 'Princess' was dropped from the pub's name to save money on a new pub sign. Ultimately, the business became insolvent and it closed in 2010, reopened briefly, but then closed again on 13 March 2010 until Friday 11 April 2014 when it reopened once more, but this time as a pub with the famous back room returned to its original open beer garden layout.

The pub is no longer trading as a music venue, but the present landlord is willing to accommodate live music on occasions, mainly acoustic sessions during term time because, somewhat ironically, he has no wish to disturb the students who now live above the pub in converted student accommodation.

The history of the building reaches back much further than the era of Britpop. In 1892, for instance, the landlord was Joseph Teesdale. A pawnbroker, Richard Horne, operated from the next building, and opposite, on the other side of Newarke Street was the well-known Justice of the Peace, Samuel Bankart. The pub, of course, takes its name from Princess Charlotte (1796–1817), daughter and only child of George, Prince of Wales, and later George IV. Her death, after childbirth and aged just twenty-one, led to national mourning. Whether there was an earlier hostelry on this site is not clear, but it would seem likely that the present building was constructed sometime in the early decades of the nineteenth century.

19. The Bowling Green, formerly the Polar Bear, Oxford Street

An internationally recognised logo which was designed by a Leicester art student gave this ancient hostelry its last name. Generally regarded as the oldest public house in Leicester, the Polar Bear in Oxford Street was originally called the (Old) Bowling Green which it has now reverted to. It was also known as the Fullback & Firkin in the 1990s.

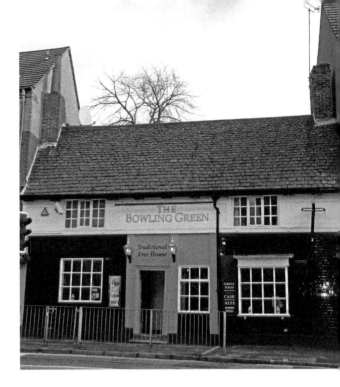

The Bowling Green, also known for some time as the Polar Bear after the mints logo.

It is a Grade II-listed building, and English Heritage suggests that it dates probably to the early eighteenth century, although the interior has been very much altered, and the rear extension is more recent.

The Polar Bear refers to a large image of the animal which for many years was visible on the adjacent Victorian building in which was Fox's Glacier Mint factory. The company was set up in Leicester in 1880 by Walter Richard Fox as a wholesale grocery and confectionery business, and by 1897 was manufacturing over 100 different confectionery lines. Now known as Big Bear Confectionery, the company's head office and one of its manufacturing plants are still in Leicester although it is now owned by the Finnish food company Raisio Group.

The pub is popular with students and staff from the neighbouring De Montfort University, and coincidentally it was a former student of this institution, known then as the Leicester College of Art, who designed the famous Polar Bear logo which is still seen today in shops and supermarkets worldwide. Clarence Reginald Dalby was also one of the first artists to work with Revd W. Awdry on his famous *Thomas the Tank Engine* books. His creation for the confectionery business was nicknamed Peppy, after peppermint.

20. Sir Robert Peel, Jarrom Street

The Sir Robert Peel dates back to the middle of the nineteenth century. The records of landlords include one William Higgs from 1855 to 1864 during whose tenure the pub's address is given as Asylum Street. Peel was the British Prime Minister for two terms of office from 1841 to 1846, and his face can be seen on the outside of the building. One notable landlord was Arthur Pougher (pronounced 'Puffer'), a professional cricketer who played for Leicestershire. His distinguished career later involved him joining the staff at Lord's where he remained for twenty-three years.

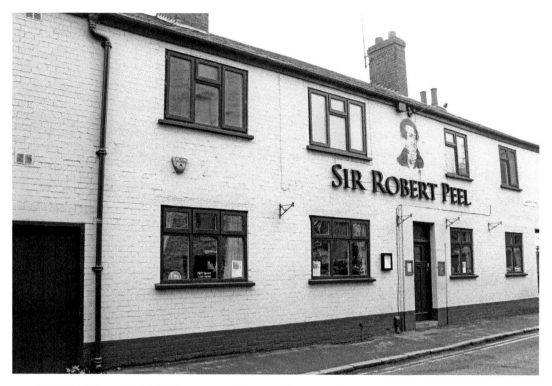

The Sir Robert Peel. The famous cricketer Arthur Pougher was once the landlord here.

In 2007 Everards launched their Project William scheme, named after William Everard who founded the brewery. The concept is to work with craft-beer producers so that their real ales are made available alongside Everards' own beers. A refurbishment of the Sir Robert Peel which cost £150,000 was part of this scheme. Today, a blackboard next to the bar lists the real ales that are on tap, often including a dark beer, as well as those that will be available in the near future.

Midway between the Leicester Royal Infirmary's Maternity Unit and De Montfort University is undoubtedly a valuable strategic location for any Leicester pub. With over 21,000 students and 3,000 staff, although not all in residence on campus at the same time, there should be enough academic clientele to fill this pub to capacity on any night of the week, as well as the number of fathers-to-be who are waiting for the moment when they need to return to the Maternity Unit to greet their new offspring.

Of some relevance is the fact that Peel set up the Metropolitan Police Force (known popularly as 'bobbies' after his first name and less affectionately as 'Peelers' from his surname) which led to other forces being created across the country, one of their purposes being to keep law and order in the ale houses of the kingdom. He is documented as saying, 'The police are the public, and the public are the police'. Of no relevance except possibly to those who devour pork pies, Peel is also credited in rearing a species of sheep known as the Tamworth Pig while he was living in the Midlands.

21. The Salmon, No. 15 Butt Close Lane

A new type of pub was born with the Beer House Act of 1834 which led to the issue of thousands of licenses for small working-class beer-only taverns, mostly situated in densely-packed residential areas of cities. The political aim was to encourage workers away from drinking cheap gin. These were modest buildings, sometimes with a skittle yard at the back and occasionally with a long room where a piano could be played to accompany songs. Many were simply ordinary houses converted into a local by turning the front room into a public bar. The Salmon is an increasingly rare example of this type of establishment.

In the 1860s, soon after the pub was built, the publican of the Salmon was named as Thomas Henry Dexter, and he lived with his wife on the premises. The street's name dates to the sixteenth century when Elizabeth I donated an area of open land to the freemen of Leicester for archery practice. The area remained relatively open until the growth of the hosiery, boot and shoe trade in the middle of the nineteenth century, which is when the pub was constructed. By 1886 there was an entire terrace of buildings along Butt Close Lane, but the Salmon is the only one to survive.

At a time when the circus was a regular and popular event in Leicester, the pub gained an extra visiting drinker in the unlikely shape of an elephant. The circus animals were stabled in the Causeway Lane area, and would be led by the side of the Salmon on their way to Churchgate and thence to Humberstone Gate. On the way, if the pub's sash windows were open on perhaps a warm summer's day, one elephant would help himself to any pint of ale carelessly left unattended on a table within reach. In the early years of the twentieth

The Salmon Inn, a typical Victorian 'corner house' pub near Leicester's Churchgate.

century before the motor car became the dominant means of transport, horse-drawn carriers would bring goods and passengers into this part of Leicester from the surrounding villages, the horses being stabled at the Salmon until the afternoon journey home.

A good example of a Victorian 'street corner' public house, this building of considerable character, tucked away behind the Highcross Centre at the junction of Butt Close Lane and Blake Street, is now in the Churchgate Conservation Area. It is surrounded by a diverse array of buildings including the famous Unitarian Great Meeting chapel, the far more recent Saxon House, and a very rare example of a hosier master's house and workshop built about 1850 and now Grade II listed. Allegedly, a tunnel once existed between the pub and the Great Meeting House nearby in East Bond Street which is now filled in. There appears to be no logical reason why such a tunnel should have been excavated.

The Salmon reopened in 2011 and won CAMRA's Pub of the Year Award for Leicester just twelve months later, and again in the following year.

22. The Musician, Crafton Street and Clyde Street

Here is a pub you are unlikely to stumble across by chance. It is a place that customers know by reputation, word of mouth and by online marketing. It is hidden away in

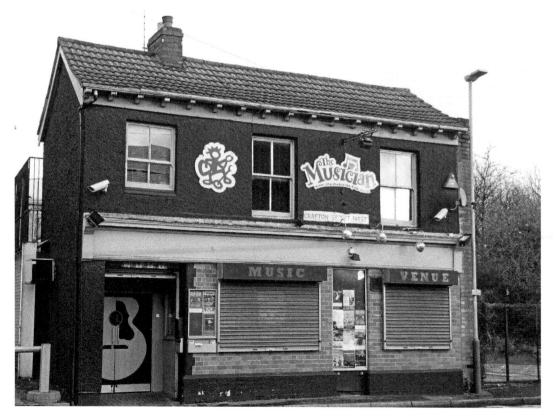

Leicester's unique live music venue, The Musician.

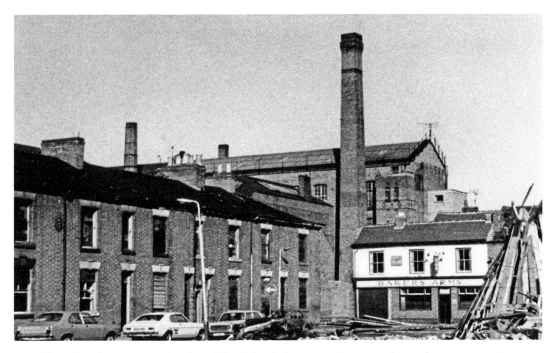

The Musician as it used to be – The Baker's Arms serving a working-class community.

a quiet back street in the maze of lanes, car parks and industrial units that occupy the area between Humberstone Gate and Wharf Street. Since it opened in 2000 The Musician has gained regional status and recognition as one of the top independent music venues, not just in Leicester but in the entire Midlands. There is live music for six days every week, sometimes seven, and the choice of musical styles is as eclectic as it comes, including contemporary singer-songwriters to rock, blues, folk, ska, punk, world, bluegrass, reggae, metal, soul, indie, avant-garde and Americana.

As well as live music, The Musician stages live comedy shows once a year, hosting events which are a part of Dave's Comedy Festival. It's also hosted *BBC Introducing* which provides a broadcast platform and recognition for up and coming young artists, described as 'unsigned, undiscovered and under the radar music'.

This is a hostelry that seems to have moved, or at least changed its address. For more than a century the building was known as the Baker's Arms, and its address was No. 34 Crafton Street. Its current address is No. 42 Crafton Street West, but it is regarded by many as being located in Clyde Street. In the mid-nineteenth century it accommodated a bakery as well as an alehouse, hence its title. Mrs Catherine Fanny Wilkins is listed in the street directories of the time as both baker and landlady. Until the slum clearances which began in the 1960s, this area was occupied by many rows of small red-bricked terraced houses, nestling in the shadow of textile factories and other manufacturing businesses. Joseph Merrick, the so-called 'Elephant Man' was born nearby, in 1862, just across Wharf Street in the second house in Lee Street. Hence there was a busy, but poor, working-class community which the publican and baker could serve.

The redevelopment of this area has been piecemeal. In the 1970s, some of the land became used as unofficial car parks for the offices and businesses on Humberstone Gate and the Lee Circle area, and a number of small industrial units were built; but the lack of residential accommodation meant the old pub had no close clientele. By the 1990s it had closed and was boarded up.

The first attempt to breathe new life into the pub as a live music venue was made by Jim Kelly, a local property developer who had aspirations to open or reopen similar pubs across the country, each rebranded as The Musician. It was not successful until the experienced Darren Knockles, formerly of the Royal Mail pub in Leicester, took over as landlord in June 2000. The venue could accommodate 120 people and was frequently packed to capacity. In 2005, a new extension was added and facilities upgraded to provide for a maximum of 220 music lovers.

Today, the two surviving sections of Crafton Street are separated by the busy St Matthew's Way, and have no joint identity, and the Musician attracts its clientele from much further afield.

23. The Bridle Lane Tavern

For over forty years, this modest pub, well away from the centre of the city and serving a community affected by waves of slum clearances and rebuilding, was obscured and hidden from view by the gaunt and increasingly depressing grey concrete presence of the Belgrave Flyover, but sunshine finally returned in 2015 when the flyover was demolished.

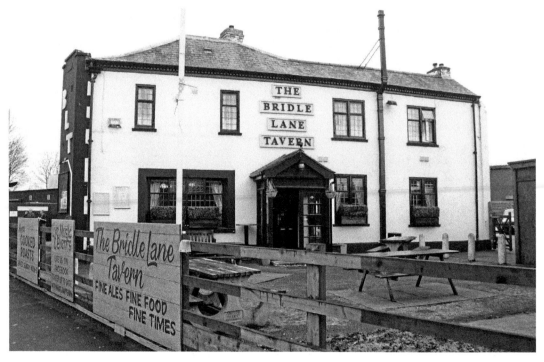

The Bridle Lane Tavern on the line of the ancient route towards Belgrave.

On the edge of the former Wharf Street area, which is now the St Matthew's Estate, the tavern takes its name from an ancient bridle way that crossed the fields, linking this corner of Leicester with the road to Belgrave before the Victorian ribbon development along the main routes into the town came into being. Junction Road follows the line of the Bridle Lane, hence the pub's address, No. 2 Junction Road. Cockshaw's 1828 map of Leicester still shows a short length of the Bridle Lane connecting Russell Square with the Belgrave Road. Crammed into this space were over sixty small dwellings, almost all providing a certain trade or service, from dressmaking to bootmaking, pawnbrokers, cycle machinists, druggists, printers and confectioners. All were demolished in the post-war slum clearances, replaced by small office and factory units.

It was probably built during that same period. In 1870, the *Leicester Chronicle* reported that the certificate (license) of the 'Bridle-lane Beerhouse' had been transferred from Harriet Davis to her husband Walter Elton. It is a former Everards house but is now owned by a small independent brewery.

Several of the oldest of our hostelries enjoy a shared reputation for being haunted. The former Freewheeler in Churchgate is probably the most notorious where, it seems that a former landlord, Harry Staines, died in 1896 at only twenty-nine years old having fallen down the steps leading to the cellar and in 1972, an exorcist was summoned to the premises after staff reported seeing a strange ghost which would change shape. But the Bridle Lane Tavern may claim to have the strangest and most spine-chilling ghostly story to tell. Nearby, an old man claimed that he had a ghostly encounter with a group of burning or burned children who were walking toward him. Several paranormal researchers have investigated this sighting but without any tangible results.

The new open landscaping of the junction of Belgrave Gate, Belgrave Road, Abbey Street and Dysart Way is bringing a new vigour to the area which went into decline when the nearby textile factories of Corah and T. W. Kempton closed down. The flyover, which opened in the early 1970s, was intended to connect the city to the Golden Mile of Belgrave Road, but achieved the exact opposite making it difficult for pedestrians to cross the area.

24. The Parcel Yard, No. 48a London Road

From the outside, looking more like a shop frontage, and situated adjacent to the Leicester railway station, this enterprise by the Steamin' Billy Brewery Co. Ltd, takes its name from the former use of the building as a sorting office for British Rail and the Royal Mail.

Until the expansion of the UK motorway network and the management of freight and parcel deliveries using sophisticated digital tracking and logistics, the bulk of the UK's manufacturing products were delivered by rail. To maximise on time, much of the sorting of letters and parcels was undertaken on board special Royal Mail trains which sped across the country every night before being delivered to towns and cities for the final part of their journey. The service acquired a much defined and almost romantic identity encouraged by the 1936 documentary film produced by the GPO Film Unit with a poetic commentary by W. H. Auden and music by Benjamin Britten. In May 2014, Royal Mail issued a set of postage stamps celebrating this and other films by the unit.

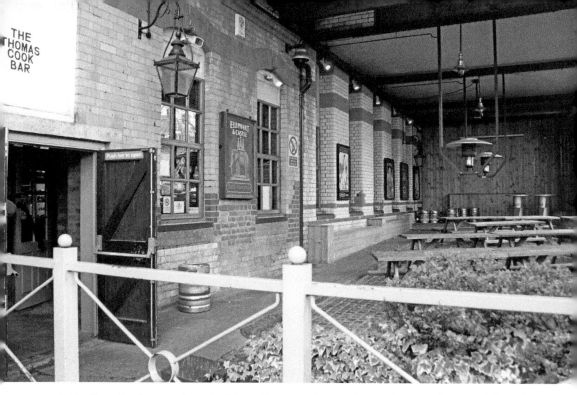

Quite literally, the parcel yard of the railway station, and now the outside area of the pub.

Knowing the time has always been of great importance to railway operators and post office staff, as well as pub landlords. The nearby turret clock is the only hand-wound station timepiece in the country, but remains very reliable. Consulting a much smaller timepiece, but still related to the railway age is Thomas Cook. His statue, by James Butler, stands on forecourt of the station outside the Parcel Yard. It was unveiled in 1991, to celebrate the 150th anniversary of Cook's first railway excursion which took workers on a trip from Leicester to Loughborough. The train departed from nearby Campbell Street, the site of the first railway station built by the Midland Counties Railway. However, Cook's strong Temperance and nonconformist beliefs would have meant he would not have approved of alcohol being dispensed here. Indeed, his own Temperance building still stands just down the hill in Granby Street, now used as shop premises and threatened with demolition.

25. The Marquis Wellington, London Road

Regular pub-goers frequently comment about the refurbishment of their favourite local with observations such as 'it isn't what it used to be', but often forget the pub as they remember it was probably the result of at least one major refurbishment or rebuilding, dating in some cases from before they were born.

The Marquis Wellington is an attractive and delightful case in point. The ornate frontage with its highly decorated leadwork suggests a period and style that conflicts with the date of 1907 displayed on the central bay. In fact, this date records what was probably the Marquis' first-ever refurbishment, by the celebrated Leicester-based

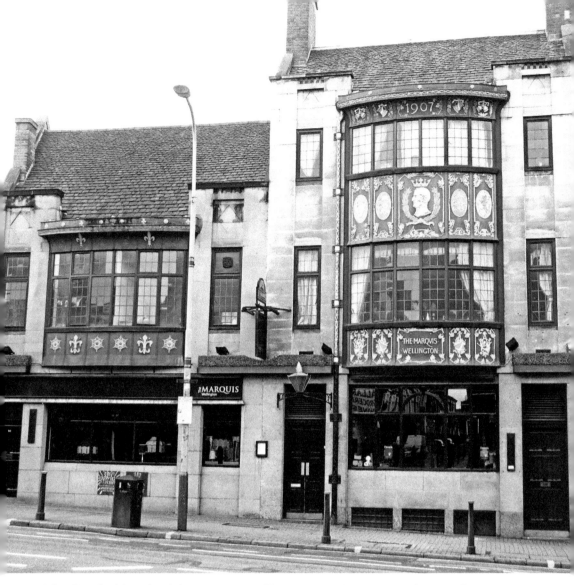

The dignified façade of the Marquis Wellington on Leicester's London Road.

architect Samuel Perkins Pick. Pick was born in Kettering, educated at Kibworth Beauchamp Grammar School and travelled widely across England with local watercolour artists Harry Ward and John Fulleylove. While the artists painted, Pick made architectural drawings from the historic buildings he came across. Hence he was able to bring many fresh and often entertaining ideas to the buildings he designed in Leicester including the Marquis Wellington. He later became a partner in the practice which still carries his name today, Pick Everard. Incidentally, this firm is closely associated with the original brewery partnership of Everard & Hull. The pub was refurbished in 1985 and again in 2008. An early photograph taken just before Pick's rebuilding shows that the pub was tied to the Everards Brewery, as it still is today. It must therefore be one of the company's oldest tied houses, being founded in 1849.

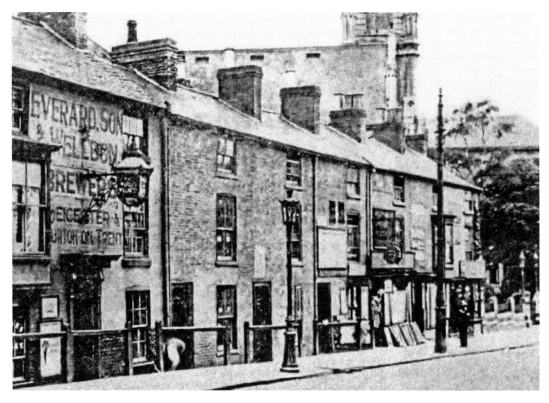

An early photograph of the Marquis Wellington before being rebuilt in *c.* 1907.

When the original Marquis Wellington was built it looked out across the London Road to open fields. It was not until the later decades of the nineteenth century that the area now known as South Highfields was developed. London Road was part of the old Loughborough to Market Harborough turnpike, the original A6 route through the county, and a toll gate (or bar) stood outside the Marquis Wellington until 1851 when a new gate was built near to where the Mayfield roundabout now stands at the corner of Victoria Park.

In recent years the building has attracted the attention of ghost watchers and paranormal investigators. It is claimed that a shapeshifter haunts the premises which turns from a cat into human form. An investigator of a different kind is also said to be present, namely the ghost of Francis 'Tanky' Smith, the private investigator and Leicester's first detective, who built the nearby Top Hat Terrace, which has been encountered stalking the rooms.

Arthur Wellesley was created Marquess of Wellington after the Battle of Salamanca in 1812, and was given the higher honour of Duke of Wellington in May 1814. It can therefore be postulated that the pub received its name sometime between these two events.

The pub is a regular venue for numerous local societies and groups, but one of the most exceptional visits was probably playing host to all eighty members of the Pontarddulais Male Choir who were performing at the nearby De Montfort Hall. They sang as well as presenting the usual form of payment for their supper, and it was said by some members of the audience the gusto with which they performed was due to their first taste of Leicester ale.

26. The Old Horse, London Road

Situated opposite Victoria Park and next door to the impressive Church of St James the Greater at the summit of London Road is the Old Horse. This was the old turnpike which rises steadily from the centre of Leicester on its route south, with the Old Horse built as a coaching inn in the early years of the nineteenth century, although little of its original structure is visible today. It was built on land owned by local landowner Thomas Miller. The toll gate was quite near to where the Mayfield Road roundabout stands today. For a short time, it was known as the Old White Horse, and both names echo its connections with the racecourse which was located opposite in what is now Victoria Park, and the heavy working horses that pulled the carriages up the hill. The 'old' horse referred to the horse that had brought the carriage or coach as far as the inn. The 'new' horse would be waiting in the stables ready to be harnessed for the next stage of the journey, so the pub's name does not celebrate one particular vintage animal.

In 1878 the Corporation moved to close the pub down but the magazine *The Midland Jackdaw* produced an article vigorously criticising their move and the pub was reprieved. It was bought by Everards Brewery Ltd in 1894 for the sum of £6,450.

Its principal claim today is that it has probably one of largest pub gardens in the area equipped with extensive heating and lighting. Customers can also play a game of pétanque and meet the other residents, namely a number of friendly barn owls who live in part of the former stables. In 2015, the Old Horse gained Leicester CAMRA's Cider Pub of the Year award.

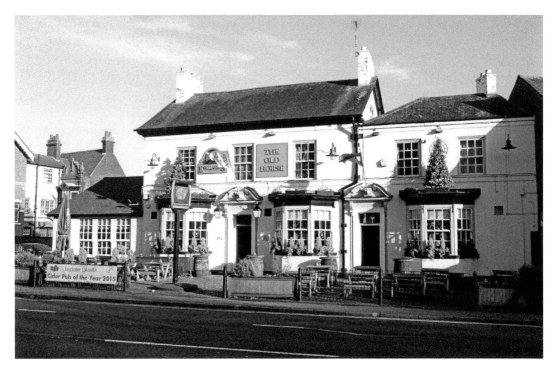

The Old Horse, a coaching inn on the Leicester–Harborough turnpike.

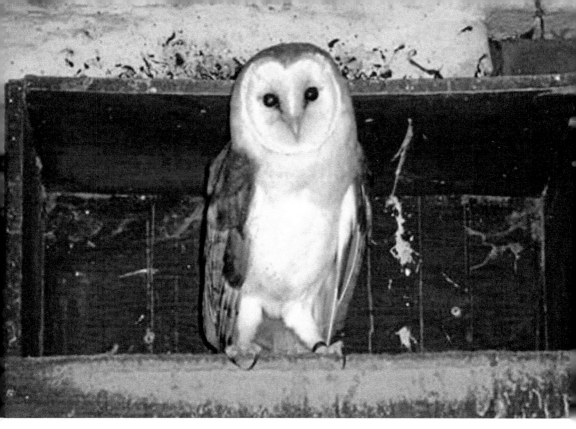

One of the residents of the Old Horse, London Road.

One of the early meetings of the Leicestershire Rugby Union, just three years after its formation, was held at the Old Horse, somewhat surprisingly because many of the teams in the earliest years were based on churches and Sunday schools. The meeting took place on 24 September 1890 and was attended by representatives of twelve local rugby clubs.

Nearby St James' Street was not named after the church, having been laid out before the church was constructed. The landowner provided the land for the church and the adjoining manse when the broader plans for the residential development were being drawn up.

27. The Clarendon, West Avenue, Clarendon Park

A modest building of some dignity, designed and built in the 1930s in this quiet terraced street off the busy and cosmopolitan Queen's Road, the Clarendon is famous for one conversation which took place over drinks one lunchtime back in 1987. It is a story that has to be told, but reflects in no way on the subsequent ownership or management.

The significant factor was the proximity of the Clarendon to the Hampshire Bakery shop off nearby Queens Road. Among the customers during one lunchbreak were four employees of that bakery. One of the group was Ian Kelly who happened to comment, during a general conversation, that he had stood in for a friend to provide a blood sample as part of the ongoing police enquiry into the recent Narborough Murders. The conversation was reported to the police and was the pivotal moment in the investigation. Colin Pitchfork was arrested and subsequently found guilty of the murders of Linda Mann and Dawn Ashworth. The case was notable for being the

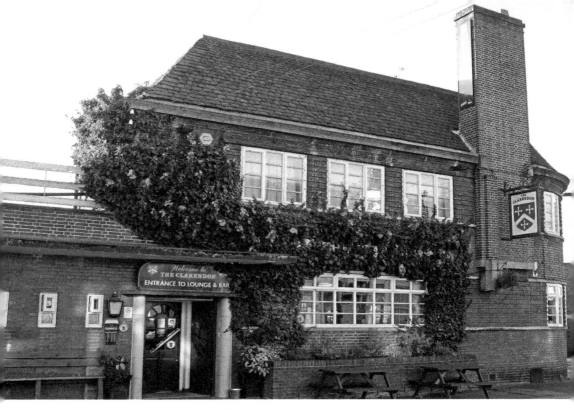

The Clarendon – an authentic suburban 'local' dating from the 1930s.

first ever criminal investigation to have been solved by using the technique of DNA fingerprinting, pioneered close by at the University of Leicester by Professor Sir Alec Jeffreys. The Clarendon Park area is popular with staff and students of the University of Leicester, given its close proximity to the campus. Ironically, it is likely that members of Jeffreys' staff were regular customers of the pub.

For the sake of perspective, this encounter was just one of tens of thousands that take place in Leicester's pubs every year. The pub is at the heart of local communities and is therefore where significant conversations may take place. These hostelries have been – and still are, even in the internet age – where local information and news is passed on.

Most of the area now known as Clarendon Park was owned by the Quakers who disapproved of the consumption of alcohol. They still meet at their Friends Meeting House nearby in Queen's Road. Hence there were few public houses in the area until recent times. Until the past decade, the Clarendon was the only pub in the neighbourhood. Its proximity to the campus of the University of Leicester has made it a popular location for staff and students and has bestowed upon the district the description 'a red brick uni nirvana.'

The pub has certainly enjoyed its fair share of news stories. One former owner Vicky Townsend, once trapped a burglar in the pub's toilets. The culprit had burgled a nearby school, and ran into the Clarendon with some of the stolen goods which included five laptop computers, a purse and a mobile phone worth more than £2,000. He was later sentenced to thirty-six weeks' imprisonment after having been released by the landlady into the custody of the police.

28. The Font, No. 52½ Gateway Street

The Font, also known locally as the Gateway is to be found in a converted Edwardian factory in the Newarke area of Leicester which was once the premises of the Harrison and Hayes hosiery company. The building has been converted imaginatively, and the pub's marketing and overall appeal makes the most of the surroundings with phrases such as 'shabby chic' and 'industrial retro'. It is, of course, located on the campus of De Montfort University and is adjacent to student apartments, hence the combination of student-orientated entertainment and amenities which include live acoustic music, poetry, beer and a three-course Sunday roast dinner from £10.00. It almost looks part of the university's rich assortment of buildings from different periods. Another interesting spin on student preferences is the provision of retroactive free-play retro arcade games and tournaments.

Gateway Street was originally Asylum Street, but was renamed in 1960. The Asylum was built in 1800 by a former vicar of the Parish Church of St Mary de Castro as an establishment for training female orphans for employment as domestic servants. It was demolished in about 1926 when a further wing was added to the Hawthorn Building which housed the Leicester College of Art and is still part of De Montfort University today. Gateway refers to the two medieval gateways to the Newarke. One is

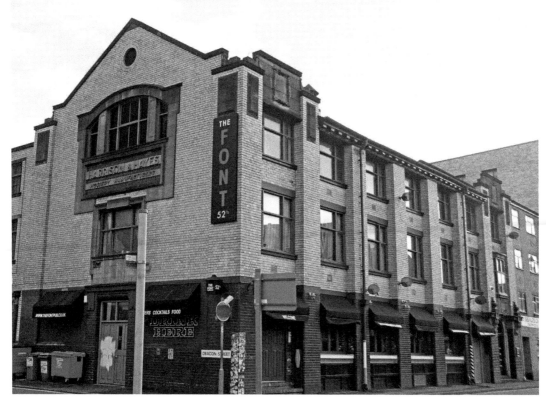

The Font in Gateway Street, occupying a former textile factory.

known as Rupert's Gateway and provided access to the walled college from the castle precincts; the other is the main Newarke Gateway which is also known familiarly as the Magazine Gateway after its military role in the Civil War and later.

29. The Counting House, Almond Street

This is an attractive landmark and listed building designed by John Breedon Everard, the founder of one of Leicester's leading architectural practices, Pick Everard, which is still active in the city today. The Counting Rooms were constructed in around 1871/72 when the cattle market was laid out on part of the old South Field of the town which had been enclosed by the town council in 1811. Thirty-six acres of the land were given to the Gild of Freemen of Leicester for use as allotments, though later cottages, shops and pubs were erected on the site. The land therefore became known as Freemen's Common.

The choice of this location as the new cattle market was influenced principally by the need for more space. The previous location was in the middle of the town adjacent to Horsefair Street where the town hall now stands. Nineteenth-century urban development meant that this market was very crowded, and the surrounding streets were left in a very insanitary state after each market day. After many complaints from the gentry of the town, the Corporation eventually decided on a move. The tracks of the Midland Railway also ran nearby which meant that a siding could be constructed into the new site to enable cattle and sheep to be transported to and from the market by train.

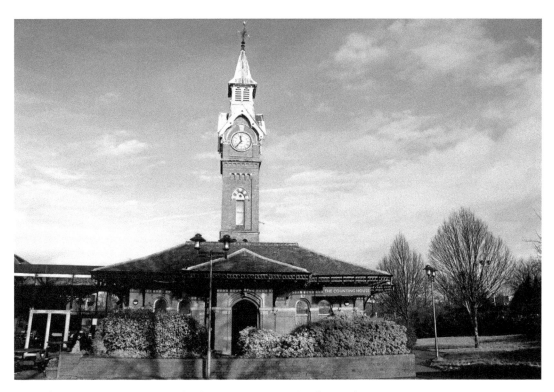

The Counting House on the former Leicester Cattle Market.

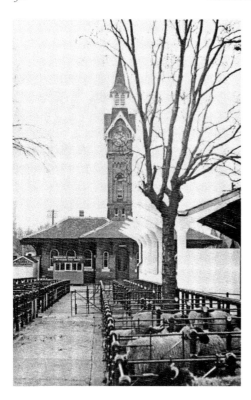

The Counting House when sheep
and cattle were the only 'customers'.

Apart from the iron gates facing the Aylestone Road, the Counting House is one of
the last structures from the former market to have survived the redevelopment into a
modern and rather bland shopping centre containing supermarkets, a multiplex cinema
and car parking. The tall clock tower at the centre of what is actually a cruciform
building still lends dignity to the scene. The pub and restaurant welcomes away team
football fans visiting Leicester, being just a few minutes' walk from the King Power
Stadium. The pub's name refers of course to the former purpose of the building as the
area where animals were counted on day of auction.

Almond Street is one of several 'nut' streets in the area including the most famous of
all, thanks to Leicester City Football Club, Filbert Street.

30. The Western, Western Road

Here is a pub that is unique. It is the first pub in Leicester to be declared an Asset of
Community Value as prescribed by the 2011 Localism Act, and it is the only pub in
Leicester with a fully functioning professional theatre.

The Western was originally the Western Hotel and was built in 1895 at the same time
that the tracks of the Great Central Railway were being laid nearby. Despite being in
competition with the Great Central Hotel nearby in Highcross Street at the junction with
Sanvey Gate (now demolished) it became very popular with railwaymen and passengers.

Close to the Western near the arches of the Great Central viaduct were several small
businesses including the Magic Polish Company. The Magic Polish Company produced

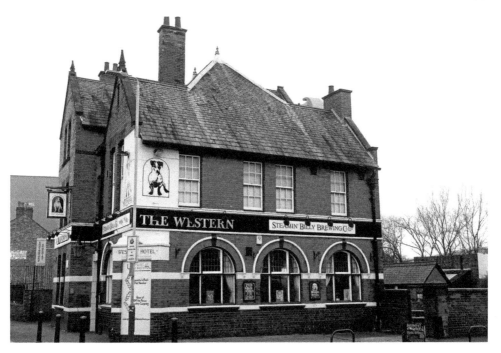

The Western – the only Leicester pub with a theatre on the first floor.

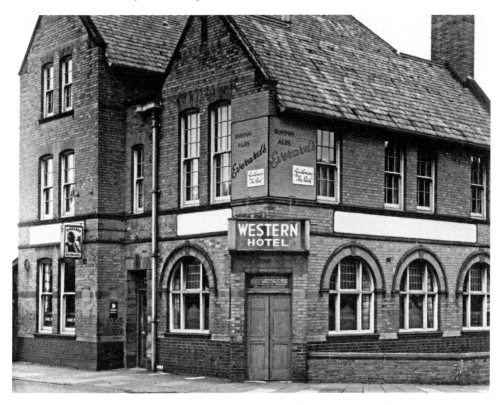

The Western was popular with workers on the nearby Great Central Railway.

an extensive range of polishes including black lead polish for fire grates, DDT polish (which was unique to them), lavender perfumed polish and red wax polish for floor tiles. They also marketed a system of shoe stretchers which went out to private purchasers, but the bulk of their output was to Woolworths with whom they had a large contract, and without which they would probably not have been able to continue for as long as they did. Their other brand name was Quickshine. Life in this small family business close by the Western is recreated in the memories of one of its employees, Brian Rowe:

It was a small family business run by a family named Potter, the owners being an ex RAF man and his spinster sister. In Kelly's Directory for 1957, the Managing Director is given as Mr Keith Potter. Mr Potter was (perhaps still is) a typical ex-RAF character complete with 'Wing Co' moustache. He drove a white Jaguar (the model with the enclosed rear wheels) and his sister drove a black Standard Eight. I was asked, occasionally, to take the Standard to a Filling Station near the Braunstone Gate end of Western Road to have the oil checked, and almost invariably found that the dipstick registered empty.

The company was eventually merged with J. Goddard and Sons Ltd, the famous silver polish company in Leicester based in Nelson Street. There were absolutely no machines at all in the factory. All the mixing of the ingredients was done by hand as was the filling of the tins, and that, in itself, was very interesting. There were, I think, three women in the filling department, and the process started by them laying out in rows, the empty tins on long flat-topped benches, perhaps fifty tins at a time, with the lids off, of course. Then they ladled out of a copper the molten polish into a jug and poured the mixture into the tins with great rapidity and skill, never overfilling, refilling the jug as necessary until all the tins were full. Then about an hour or so later, when the polish had set they picked up a pile of lids, perhaps a dozen or so, and went along the line, putting them on, again very rapidly. (We in the Packing Department always knew when they had got to that stage as it sounded like several horses clip clopping along). Then they packed the tins in two-dozen piles and wrapped them in brown paper before placing them on a rack, ready for when we needed them for an order.

I remember that one day the man who formulated and mixed the ingredients for the polishes, and who was also the Boiler man (at that time, the factory had one of the usual tall chimneys), tested various proprietary brands on a piece of slate, and our polishes beat them all hands down. I often wondered, in later years, whether Goddards knew that to be the case, and were worried about the competition.

The man in charge of the packing and dispatch, Archie Warren, was also the key holder for the factory and lived opposite at, I believe 106 Western Rd. He was a wizard with radios and was often asked to undertake repairs for the staff and anyone else.

In the office were three or four women; there was the boiler man/mixer, the three women in the filling room, and the foreman in charge of dispatch, us two packers, (and in my case, also van driver), and also an elderly man who seemed to do odd jobs, and sweep up. There was also a man named Smith, very dapper, and always in a three-piece suit and trilby hat, who came each day, and went into the office and then greeted us before leaving. I think he was a Director, and possibly related to the Potter family.

For many years tied to Everards, the Western is now associated with the Steamin' Billy Brewing Co. Ltd. The name has no relation to the former railway line (presumably the locomotives were puffing billies).

The Western is located near Bede Island which for decades was an industrial backwater dominated by scrapyards and other industry. Ironically, locals felt that the existence of the pub was threatened by the clearance of those industrial enterprises which were replaced by student accommodation connected to De Montfort University, which is why it was moved that the Western should be declared an Asset of Community Value. It means that should the owners decide to sell, the local community or City Council must be given the opportunity buy it.

The pub's location is ideal for celebrated or drowning sorrows after a Leicester City or Leicester Tigers match. It has a large beer garden a log burning fire, regular events including beer festivals, poetry nights and music gigs; but it is the theatre which is its main claim to local fame.

While looking for rehearsal and performance space in 2012 Artistic Director Gary Phillpott and Producer Verity Bartesch discovered the empty upstairs room at the Western. As a result, a successful run of Loughborough writer Thomas Scully's play *Godot Was Here* took place in October 2012 which marked the creation of *Upstairs at the Western*, Leicester's first pub theatre.

The walls were painted in 2013 and seating hired. A bespoke (and unique) stage was constructed, resting on beer kegs. The first season during March and April 2013 featured no fewer than twenty-one performances which gave audiences many opportunities to experience a wide variety of culture at affordable prices. There are now two seasons of performances in spring and autumn every year.

31. Verd'e, aka Bar 66, Braunstone Gate

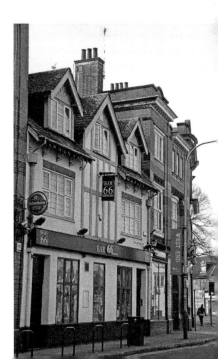

Bar 66 exemplifies the lively nightlife of Braunstone Gate.

Before the extension to the Narborough Road South – the route of the Roman Fosse Way – was constructed, the narrow twisting Braunstone Gate was one of the main routes into the city from the west and south west. There were few crossing points over the River Soar, and there was much needed engineering work to improve sewerage and flood alleviation in the 1830s which led to the Braunstone Gate Bridge being constructed, with Braunstone Gate leading to it.

Given that this route now carries much of the traffic leaving the Midlands motorway network heading for Leicester, the development, which bypassed Braunstone Gate, was absolutely essential. Since the modern road scheme, which diverted the traffic to St Nicholas Circle was completed, Braunstone Gate has transformed itself into a vibrant and very popular centre for eating, drinking and entertainment, with a fascinating variety of bars, restaurants and independent shops. Bar 66 advertises Big Screen football, great DJs and music until 2.00 a.m. Those who seek a traditional pub atmosphere may need to look elsewhere.

Several of today's modern bars were formerly traditional public houses. Bar 66 took its name from the pub's address (Nos 64–66 Braunstone Gate) and was built as the Freemasons Arms. It became the Braunstone Gate Brewery in about 1890 and was rebuilt in the 1920s as the Braunstone Gate Inn.

32. The Black Horse, Foxon Street

If the original regulars of the Black Horse were able to return to the Black Horse today, they would not only be surprised by the glitter and the noise of today's Braunstone Gate, but also by the fact their old watering hole is now painted a rather vibrant blue. Until 2013 it was a more sedate white-fronted building with windows and doors painted in 'Everard's green'. The pub's address was originally No. 28 Braunstone Gate, but is now No. 2 Foxon Street.

Standing on the corner of the two roads, this is another typical Victorian corner pub, built when the terraced streets were laid out in the mid-nineteenth century, although at some stage it has expanded to occupy the adjacent three premises, and now runs the full length of what remains of Foxon Street. A great many very small businesses operated from these corner buildings at some time in their history. In the 1880s, for instance, the son of the landlord of the Black Horse ran a shoe repair business from the pub's upstairs rooms. The building is now protected by being on Leicester City Council's Heritage Asset Register. Foxon Street once led to a number of similar small streets, but these were demolished in the late 1970s. A Tesco supermarket store and car park is now on the site.

There are numerous pubs named after a black horse. Some are derived from the nickname for the 7th Dragoon Guards who wore black collars and cuffs on their jackets and mainly rode black horses. The regiment was raised in 1688 and were amalgamated into other regiments in 1922. However, a counterclaim is that the name is linked to the famous horse who belonged to Richard Neville, 1st Earl of Warwick, which was called Black Saladin. If there is any truth in this story, then there is certainly some local relevance, as Neville, also dubbed Warwick the Kingmaker is said to have founded the old grammar school in Kibworth Beauchamp in Leicestershire.

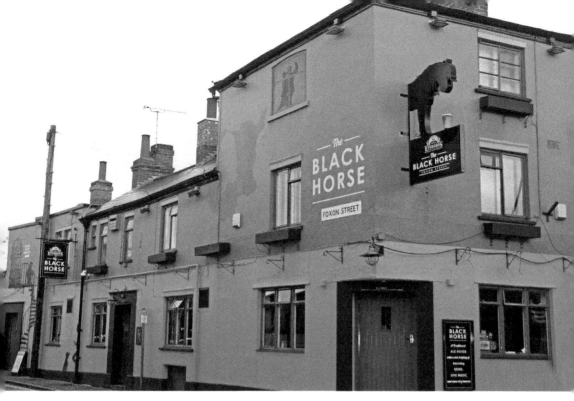

Above: The Black Horse, once a small neighbourhood pub that has survived and expanded.

Below: The Black Horse once served a small working-class community near the West Bridge.

Chapter Three

Further Afield

33. The Cradock Arms, Knighton

Originally called the Bull's Head, this hostelry of considerable character on Knighton Road was formerly the village pub when Knighton was a settlement in its own right and still separate from Leicester. Part of the timber-framed building probably dates to the early seventeenth century.

Curiously, the arms that are displayed outside the pub are not those of the Craddock family, but of those belonging to Alderman Gabriel Newton who, as well as trading in wool and serving as Mayor of Leicester, was also for some years the landlord of the Horse & Trumpet in the city which he inherited from his father. Coincidentally, the Craddock family were also merchants, and Edmund Craddock, a woollen draper, was a contemporary of Alderman Newton, acquiring Knighton in 1720. He constructed Knighton Hall on land known as Nether Town Close, and the sharp bend in Knighton Road near the pub was caused when the route was diverted away from the hall in order to provide the family with more privacy.

Joseph Craddock, who died in 1826, was an antiquarian who devoted much time to exploring his family's history. He decided that his surname derived from Caradoc or Caractacus, leader of the Catuvellauni tribe who was defeated by the Romans in battle somewhere in the Malvern Hills. Craddock believed that the remnants of the family fled across the borders to safety in the region occupied by a tribe that would not hand them over to the Romans, and eventually settled in the Leicester area.

Craddock also owned the manor of Gumley near Foxton in south Leicestershire where he built Gumley Hall. This is a village which also satisfied his interest in history. The village is first mentioned in 749 when King Æthelbald of Mercia (r. 716–757) held a synod (or legal gathering) in the village. King Offa visited Gumley in 772 and again in 779 for a witanagemot (another form of legal gathering) of the Kings of Mercia.

The Cradock Arms was acquired by Everards Brewery in 1925 and was extensively refurbished in 2010 at a cost of £350,000. During an earlier refurbishment it is said that five Roman pots were discovered in the area of the car park during the building work, but their present whereabouts is not known. Local village folklore claims that the Craddock family purchased the pub from the church, but that the religious

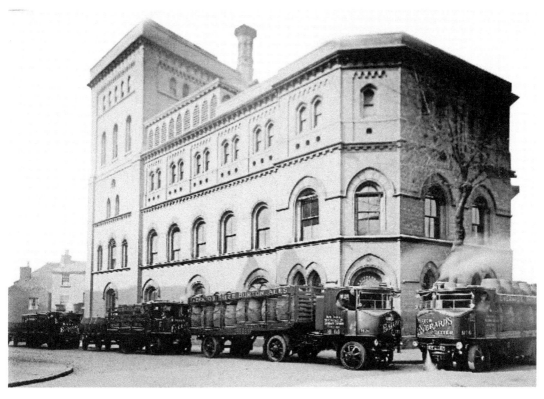

The original Everards Brewery in Castle Street.

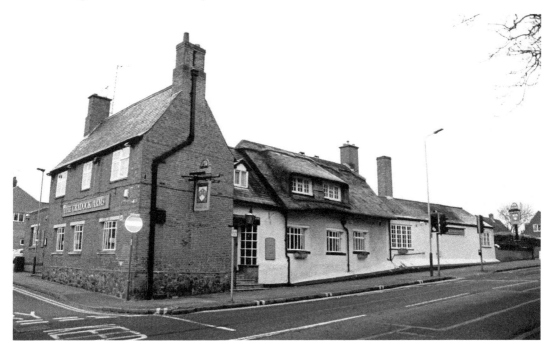

The Cradock Arms in Knighton, dating to the early seventeenth century.

authorities insisted that the family could not be seen to be benefactors of the church as well as owners of the village pub. Consequently, the name of the pub was changed by removing one 'd' from its name, changing Craddock to Cradock.

34. The Black Dog, London Road, Oadby

The Black Dog was refurbished by Everards in 2014 but still retains the character of a village pub, even though Oadby is no longer surrounded by green fields. The pub was built in 1787 and brewed its own ale for over a century. There are local legends of a tunnel linking the pub with the nearby Parish Church of St Peter's. Indications of a bricked-up underground entrance to the cellars tend to support this story. The Black Dog is also said to be haunted perhaps because the skittle alley was once used as the village mortuary.

Next door to the pub lived the well-known poacher James Hawker, one of the most colourful characters in Oadby's history. Born in Daventry in 1836, as a small boy Hawker was sent to work in the fields as a bird scarer. His first week's wages earned his family enough to buy one small loaf of bread. He began poaching when still in his teenage years and joined the militia so that he could acquire a gun. In 1893 he was elected to the School Board in Oadby where he sat next to the landed gentry on whose lands he poached. He also became a member of the parish council. He has

The Black Dog in Oadby.

been described as a man of little education but keen intelligence, and he was certainly a radical thinker who loathed privilege as this unedited and angry quotation from his journal indicates:

> If i Had been Born an idiot and unfit to Carry a Gun but with Plenty of Cash they would Call me a Grand Sportsman but for being Born Poor i are Called Poacher.

It is probable that little of Hawker's colourful life would be known today had he not kept a journal, written in 1904 and 1905 and described as a mixture of autobiography, poacher's handbook and radical philosophy. It was published by Oxford University Press in 1961, and a play *The Poacher*, based on his life was written by Andrew Marley and Lloyd Johns and produced by the Emma Theatre Company in 1980. He died of a heart attack in 1921 near Stoughton Road and lies buried in Oadby cemetery. A collection after the first performance of *The Poacher* raised money to pay for a headstone on Hawker's grave.

Today, the clientele of the Black Dog is probably not so colourful as James Hawker. No doubt he would have appreciated the warmth of the pub's log fire, and perhaps the conviviality of its food, but as a supporter of the Temperance movement he would have declined the fine ale.

35. Glen Parva Manor

A real manor house which represents where this small but ancient village began as a settlement beside a ford across the nearby River Sence. The area is now called Glen Ford, and just over 100 metres from it is this splendid early post-medieval manor house. Between the present house and the river is much evidence of the past including a moated site where an even earlier manor house probably stood. Archaeological excavations in 1962 revealed a possible roundhouse with a hearth, oven and cobbled floor surface associated with the late Bronze Age.

Glen Parva Manor is Grade II listed. It was built sometime at the turn of the sixteenth and seventeenth centuries with a timber frame and brick infill, although the painted signage claims a much earlier date of 1452, possibly the date of the first structure on this site. The Lord of the Manor in the sixteenth century was Ambrose Belgrave, but after his death in 1576 it is unclear who inherited or acquired this modest but fine building. When John Nichols wrote his *History of Leicestershire*, which was completed in 1615, the Lord was Edmund Major of the Northamptonshire Militia. His descendant, also named Edmund, served as High Sheriff of Leicestershire in 1824. In 1861 an additional large rear wing was added and there was a further extension in the twentieth century.

Both extensions have succeeded in being in keeping with the satisfying appearance of the house's original architecture. Most noteworthy is the medieval timber-framed style construction with brick panel infill and the ornamental barge boards to the back roof and side entrance porch, with the entire roof made of local Swithland slate. Inside, the original fireplaces, exposed beams, trusses and joints are all maintained to be enjoyed.

Above: A very ancient inn, the Glen Parva Manor.

Below: The old Glen Parva Manor building has been tastefully extended.

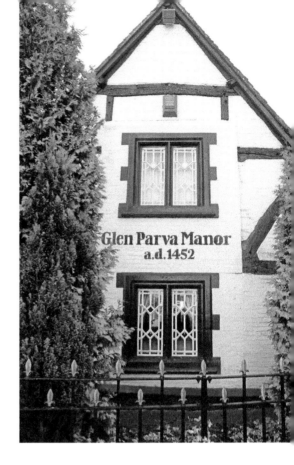

Glen Parva Manor was built where a ford once crossed the River Sence.

The more modern history of Glen Parva includes the novelist and writer Sue Townsend who grew up here. It has been speculated that many of the locations and characters in her books, including Adrian Mole, are based on local places and people. If this is the case, and given the very small population and spread of buildings, the people who have partaken of food and drink at the Manor must surely feature.

36. Grange Farm, Florence Wragg Way, Oadby

Strictly speaking, Grange Farm is in the neighbouring district of Oadby and Wigston, but is only a matter of a few hundred metres from the city boundary, and it is a building of immense charm and character. It was built in the mid-nineteenth century as a farmhouse, and at one time, according to the pub's publicity, it was used for the brewing of locally grown barley to meet the local inhabitant's demand for real ale. The land formerly connected to the farmhouse on which the barley once grew is now a large housing estate. Incidentally, the popularity of Barley Mow as a pub name originates from the stacks of barley delivered to any pub that brewed its own beer. Regular patrons of Grange Farm include visitors to, and the gardeners who care for, the nearby University of Leicester's Botanical Gardens, and Leicester Racecourse is just a few minutes' walk away.

However, there is a spooky twist to this hostelry. Apparently, most of the family who once owned the farm died in the building, in unusual circumstances, and it is reported

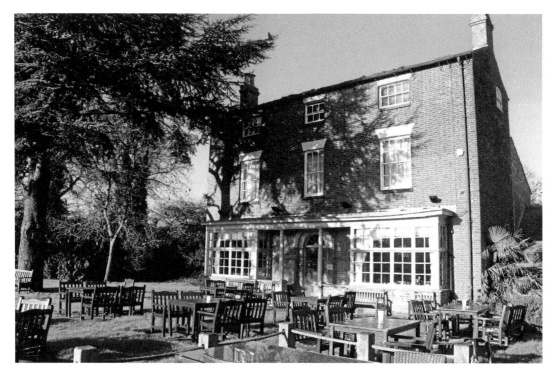

Above: Grange Farm, Oadby – the building is a converted farmhouse.

Left: Grange Farm's unusual but attractive black and white inn sign.

that they still wander around the premises presenting, understandably, a morbid countenance. Allegedly, according to those who have undertaken paranormal research, the staff room is the scariest place to be, and the toilets sometime have an odd feeling.

The road on which the pub now stands is named after the redoubtable local historian and author who wrote two histories of Oadby, *Edwardian Childhood* and *Oadby Remembered 1918–1990*, both published by the Oadby Local History Group. Florence writes movingly in her second volume of Violette Szabo, the young woman who served her country as a member of SOE (Special Operations Executive) in the Second World War and who was executed by the Nazis as a spy in February 1945. For a few years in her childhood, Violette lived in Oadby. Her father operated a taxi or car hire business. Oadby in the 1920s and 1930s was still a village. Florence wonders which buildings in the area Violette would have visited with her parents, long before she discovered her calling. Perhaps the old Grange Farm was one such place.

37. The Cricketers, Grace Road

There could only be one name for a pub in Grace Road. The Leicestershire County Cricket Club's association with the ground at Grace Road dates back to the nineteenth century, and the first pub in Grace Road was the Cricket Ground Hotel, built when the cricket club first developed the site in the 1870s having purchased the land from the Duke of Rutland. However, for many years until the end of the Second World War, the club played its matches on a ground further along the Aylestone Road in the shadow of the Leicester Power Station cooling towers. During this interregnum the pub continued to trade.

The Cricketers, Grace Road. Many a cricketing tale has been told here next to the county ground.

The cooling towers of the power station caused problems for the groundsmen, depositing a film of ash on the pitch, and the club eventually returned to Grace Road in 1946. In the early post-war years, Grace Road was not a good place to play cricket. The conditions for both players and spectators were very poor. There were only two buildings, one of which also served as a gym for the nearby school which used the ground as their sports field. There was also a piece of adjacent derelict land which was brought into use as a car park. It looked like an improvised temporary arrangement, rather than the home of quality county cricket. It was not until the 1970s that regeneration took place including the present pub.

Located by the side of the pedestrian walkway to the turnstiles at the Park Hill Drive entrance to the ground, the Cricketers is an Everards public house, and, to be expected, the bar is adorned with signed cricket bats and other associated memorabilia. There have been other pubs of the same name in Leicester. One was located in the Wharf Street area where the town's first cricket ground was located. The Musician pub in Clyde Street stands on what was the outfield.

38. The Real Ale Classroom, Allandale Road

There must be very few hostelries in the United Kingdom which describe their business, quite seriously, as educational, although no doubt for many young people the local pub plays a significant part in learning about life as they grow up. Yet, here is the Real Ale Classroom where people can be taught how to savour the finest brews and learn how

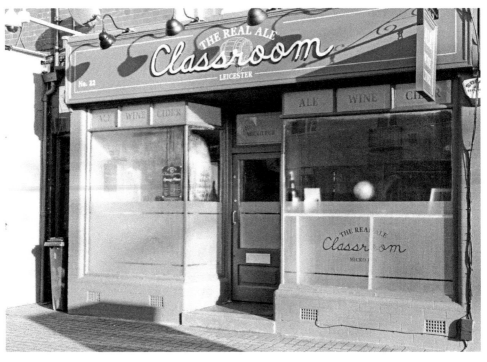

A new style of public house where customers are taught to appreciate real ale.

A blackboard informs customers of the latest ales available at the Real Ale Classroom.

Dr Thomas Arnold with an open book looks down from above the fireplace in the Real Ale Classroom.

A bar with a difference in the Real Ale Classroom.

to brew the perfect pint. A few miles south of the city in the somewhat select Allandale Road shopping area of the Stoneygate suburb of Leicester, this is a unique drinking establishment which only opened at the beginning of December 2015. Two teachers, Steven Tabbernor and Ian Martin have taken inspiration from the more usual type of classroom and added their enthusiasm for real ale to invent a new type of pub, which they have described as an 'educational ale house'.

Above the fireplace is a framed portrait of Dr Thomas Arnold (1795–1842) who was headmaster of Rugby School from 1828 to 1841. Although he is known as a reformer, one wonders whether his zeal as an educator would have encompassed teaching others about the finer qualities of real ale.

This small bar serves a range of beers, ciders, stouts, ales and perries from around Leicestershire and the neighbouring East Midland counties, and the plan is to teach drinkers about how beer is brewed and how one ale is different from another. The wide range of beers are served straight from the barrel, and even the gin and tonic is sourced from the local distillery, Two Birds.

The Real Ale Classroom is small and cramped, but that is very much the ethos of this modern micro-pub. It is not the place to go for a quiet chat in the corner or a solitary drink, but rather a pub where you will be expected to take part in the ongoing conversation about the latest local ales. Bijou, often cramped, and very sociable, perhaps this is the future for the English pub in the suburbs, away from the brashness of city nightlife?

39. The Tom Hoskins, No. 131 Beaumanor Road

Behind the modest but brightly decorated Victorian façade of this small public house, tucked away in an unremarkable Leicester side street, but not far from the National Space Centre and the Abbey Pumping Station Museum is the history and remnants of one of Leicester's oldest breweries which is sadly now defunct.

The Beaumanor Brewery was opened in 1895 by a former blacksmith, Jabez Penn, who was born, the son of a carpenter, in Barton in Warwickshire in 1843. His wife's parents managed a grocery shop in Thames Street in Leicester, and possibly Jabez gained an understanding of the retail business at that time. A near neighbour of the Langham's, John Towell, was a maltster from whom he may have learned the art of brewing, especially since Towell lived next door to the now defunct Gladstone Arms where he may have also been the brewer. Wright's Directory of Leicester for 1892 lists a Wilfrid Penn, also a shopkeeper, at No. 28 Thames Street.

Nine years later, Penn's son-in-law, Tom Hoskins, joined him from Worcestershire as a partner. He took over sole control of the brewery in 1906 and before long Hoskins beers achieved national recognition winning many awards at brewing shows. The building is a red-brick tower brewery. The mash tun, copper and fermenting vat were all installed in 1913, and remained in regular use throughout the entire life of the brewery.

The Tom Hoskins – the brewery has closed but the pub is still open for business.

Left: A founding master of brewing in Leicester, Tom Hoskins.

Below: The former Hoskins brewery, now dormant but still standing.

The brewery had a chequered history, and although its beers were always held in high acclaim and won many awards, the company suffered from financial problems in its final years of trading.

The old brewery left family ownership in 1983 when it was purchased by the Saffron Walden Vineyard and Cider Orchard Co. Numerous takeover bids and changes of management followed. In February 2000, the business changed hands again and was in the ownership of Archers who closed it down, transferring the production of Hoskins ales to its facility in Swindon. Ironically, Archers went into administration less than seven years later, and despite a buyout, closed down completely in 2009. It was reported at the time that their financial problems had been caused by trying to brew and sell too many different ales. The actual brewery is still standing, and a ghost sign can still be seen above the small beer garden by the side of the pub.

However, the Hoskins family stayed with brewing. Philip and Stephen Hoskins, with another partner Simon Oldfield, established a new business under the name of the Hoskins & Oldfield Brewery Ltd. Since 2001, this separate portfolio of Hoskins beers has been contracted out, being brewed first at the Tower Brewery in Burton-on-Trent, and then at the Belvoir Brewery, Old Dalby using the Hoskins Brothers name. The Ale Wagon in Rutland Street on the corner of Charles Street has been the principal city centre outlet for their ales.

The original Hoskins brewery only ever owned one pub which was the Red Lion in Market Bosworth, 15 miles away. Their business was concentrated almost entirely on the free trade in the Leicester area, but the building which is now the Tom Hoskins became the off-sales counter attached to the brewery, where from 1973 draught beers were dispensed. The pub was formerly the living room of the Hoskins family residence, so customers now relax where these fine brewers once enjoyed their leisure hours, while the brewing continued in the adjacent building.

40. Talbot Inn, Belgrave

The origins of The Talbot are unknown. Part of the underlying structure of the present building possibly date to the eleventh or twelfth centuries but the form and purpose of this early building is not known. Clearly, to be a substantial stone structure of that age would suggest a building of considerable significance within the local landscape.

The Talbot of later centuries was originally an inn which took paying guests. It was in an ideal position for passing trade, located on the main route on the toll road into Leicester from Loughborough and the north before the opening of the Loughborough Road route. One can imagine both familiar faces and strangers meeting in the bar, the travellers exchanging news which travelled up and down the coaching routes.

The oldest parts of the present structure are the cellars. One cellar is still in use. The other is bricked up. In the late 1950s, the inn was badly damaged by fire. In 1958, grants were obtained from the local authority to rebuild, and during the refurbishment the structure was reduced from three storeys to two. From this point, the Talbot ceased to take in paying guests.

The fabric of the inn today dates for the most part from the eighteenth and nineteenth centuries, but behind the fixtures and fittings can be seen bricked-up arches

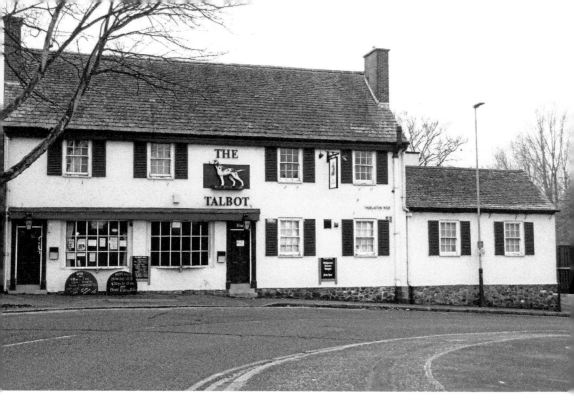

Above: The Talbot Inn is said to be one of Leicestershire's most haunted pubs.

Below: The Talbot Inn before fire destroyed the upper storey. The tree has survived to the present day.

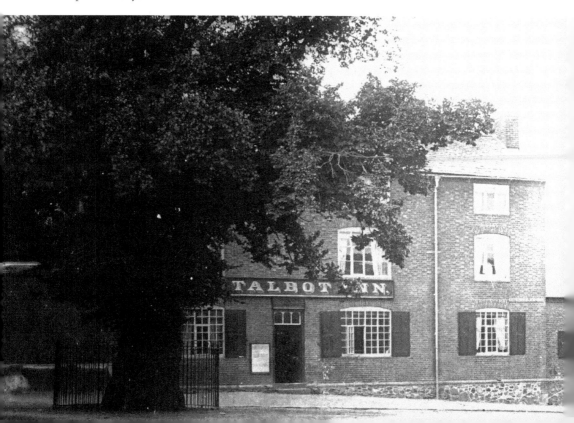

which some believe are priest holes, or possibly tunnels leading to either the nearby Belgrave Hall or the church. These three buildings have for some years been dubbed by paranormal researchers the 'Belgrave Triangle'. With Belgrave Hall, formerly a museum, now closed to the public and shuttered, and the Parish Church of St Peter's now redundant with its churchyard overgrown, there is most certainly a rather ghostly atmosphere in this quiet enclave.

Given the age of the building, it is not surprising that many paranormal experiences have been claimed within its ancient walls. According to a succession of owners and tenants, equipment in the cellar has often been tampered with and stock has vanished with no easy explanation. Several years ago, paranormal investigators, staying in the pub overnight in separate rooms, heard the sound of movement and footsteps in each other's areas.

This old hostelry's associations with the paranormal probably stem from its proximity to Red Hill, where the local gallows once stood. According to local tradition, the Talbot was often the last place where condemned prisoners stopped on their way to their execution, where perhaps they were allowed one last drink. The ghost of a man with a disfigured face has been seen, and it has been assumed that he was one of those who had been hanged nearby. It is said that part of the building, which is now used as a garage, once served as a mortuary, but whether this was where the bodies of the executed were brought back from Red Hill is not confirmed.

The figure of a lady has been seen walking through a false wall late at night. She has long flowing hair and was seen so often that the locals gave her a familiar name – Hairy Mary. It is conjectured that she is the ghost of former landlady, Mary Dawson. Certainly, at the time that the Dawsons and their six children resided at the Talbot, the living accommodation for the innkeeper was in the larger of the cellars. Today, some staff will not enter that area.

Another previous landlady saw a shimmering figure on the verge outside the building near to the car park. It was the height of a small man and it moved slightly. The landlady had been gardening and had paused to rest, feeling very warm. But what she saw made her shiver, and she later said she was frozen to the spot, unable to move through fear.

Other unaccountable appearances have included the figure of a small boy which has been seen in the fireplace of the lounge. He was sitting on a stool, swinging his legs and smiling. This boy has also been seen in the cellar by the same person, a previous tenant of the inn. A man has been seen on a number of occasions, again by previous landlords. This individual appears next to the bar and wears an old caped raincoat, carrying a leather purse. He has been seen to open the purse, look for some money and then turn to walk through the adjacent wall precisely at the point where the original entrance to the inn was located before refurbishment. A man's face has also been seen peering through a window at the back of the lounge. It is said that he is much disfigured.

41. The Cedars, Evington

The former home of a fascinating whodunnit author, the Cedars was built as a private house for a middle-class family at a time when Evington was still a village separated by open fields from Leicester and Oadby. It was constructed in about the 1830s in the style of two Leicester-based architects, William Parsons and William Flint who

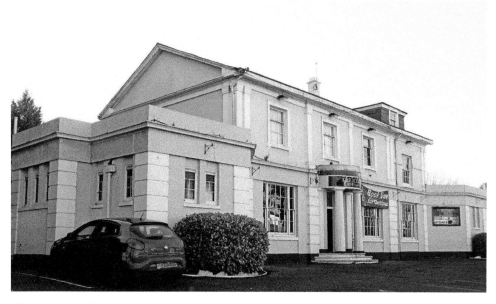

The Cedars in Evington, built in the 1830s as a refined residence in a rural suburb.

The plaque commemorating the Cedar's most famous owner, E. Phillips Oppenheim.

separately designed not only single buildings but whole areas of housing in the outlying suburbs of the city. The two side wings were added in 1937/38 when the building was converted into a hotel and licensed premises.

It seems likely that one of the first families two live in the Cedars was that of the vicar of Evington, the Revd William Burton Moore who was descended from a family prominent in Leicester's hosiery trade.

The most famous and interesting owner of the Cedars was undoubtedly Edward Phillips Oppenheim, known as the Prince of Storytellers. He was born on 22 October 1866 in Leicester, the son of a leather merchant, and after attending Wyggeston Grammar School worked in his father's business for nearly twenty years, beginning there at a young age. He continued working in the business, even though he was a successful novelist, until he was forty when he sold the business.

He wrote his first book *Expiation* in 1887. He met his wife, Elise Hopkins, during a business trip to the USA in 1890. They lived at the Cedars until the First World War. Elise remained faithful to him throughout his life despite his frequent and highly publicised affairs, which often took place overseas and aboard his luxury yacht which was called, rather poignantly, *Echo*, the initials of Elsie Clara Hopkins Oppenheim.

During the First World War, Oppenheim worked for the Ministry of Information while continuing to write his suspenseful novels. In all Oppenheim wrote 116 novels, mainly of the suspense and international intrigue type, but also including romances. He is generally regarded as the earliest writer of spy fiction as we know it today, and invented the *Rogue Male* school of adventure thrillers, later developed by authors such as Geoffrey Household and John Buchan. In his youth, Ian Fleming read Oppenheim's *The Spy Paramount*, written in 1935, set in Nice, Rome, Monte Carlo and an island in the Mediterranean, and featuring the hellnotter, a laser-like disintegrating ray. Almost certainly, this thriller set the scene, years later, for James Bond. To some extent, he also paved the way for other crime writers and fictional investigators such as Agatha Christie's Hercule Poirot and Tommy and Tuppence Beresford.

The blue plaque in the Cedars' entrance lobby commemorates Oppenheim's links to the village of Evington.

42. Ye Olde Baker's Arms, The Green, Blaby

No other public house in this book can match the history of the Baker's Arms. It dates from 1485, the year that Richard III was defeated at the Battle of Bosworth Field, and is one of the oldest pubs in Britain. It is also an exquisite building which comes as a genuine surprise to travellers who take a detour from the main streets of Blaby and stumble upon it.

This delightfully quaint thatched building was originally constructed in order to house the craftsmen who worked on All Saints Church, Blaby, and subsequently found use as the church hostel. The hostel was later converted into cottages until the middle of the nineteenth century when the pub was first licensed. In the fifteenth century the Manor of Blaby passed from the Lodbroke family to the Savile family when the last heiress of the Lodbrokes was married to a Thomas Savile. In 1484 the Bishop of Lincoln visited the church, and the clerestory windows in the nave date from this period. It was

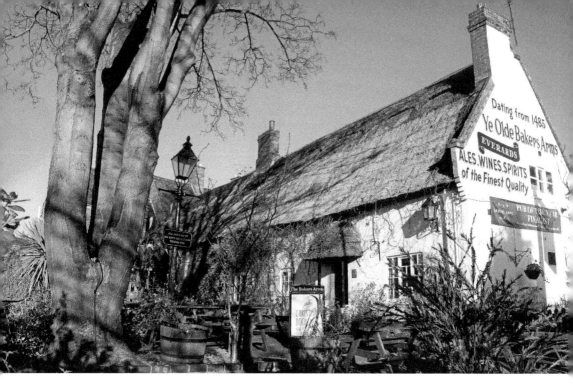

Above: The Baker's Arms, Blaby is said to date to 1485 the year of Richard III's defeat at Bosworth Field.

Below: The Baker's Arms, with possibly the largest painted inn sign in Leicestershire.

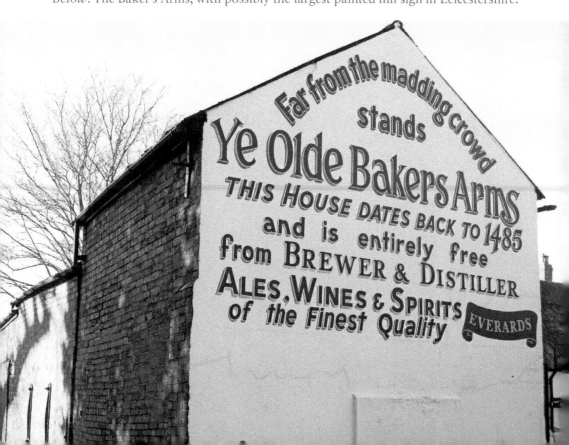

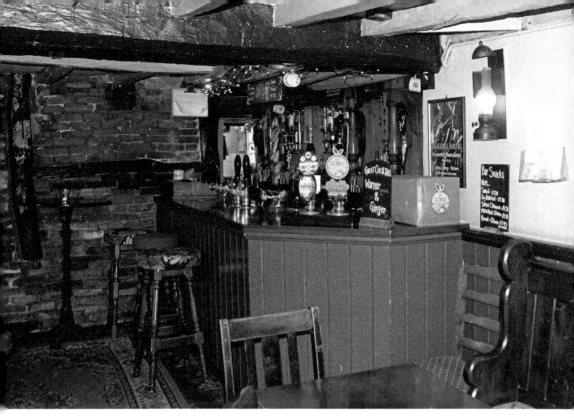

Above: The Baker's Arms, constructed to house craftsmen working on the nearby parish church.

Below: Villagers could cook their Sunday dinners in the ovens at the Baker's Arms for 1/2*d*.

The bakery museum room at the Baker's Arms.

no doubt this change in manorial ownership promoted the work that took place on the church. The Bakery was used in the 1920s, when it was still possible for villagers to cook their Sunday dinners in the hot ovens for 1/2d. It was fully renovated in 1985 by Hamden Hosts and R. E. Bates & Son.

The bakery is now a venue for small meetings and private functions, and features the original ovens, tools, character and the history of the building. There are also baking events organised by Everards Brewery and local historical and food societies including bread making courses. Other courses included in the past, chocolate, cheese and beer-making and a televised competition to produce the best ploughman's lunch.

43. The Old Crown, Moat Street, Wigston
The Old Crown is a simple straightforward pub (and little else) with a fascinating history which dates back to the 1600s. In the eighteenth century it was a haunt of the notorious highwayman George Davenport, who, more than once, danced a jig on the pub's roof to a tune he named as Astley's Hornpipe. Davenport obviously kept up with the top tunes of the day, as this tune was written by a contemporary character, Philip Astley. Astley was born in Newcastle-under-Lyme in 1742, and Davenport in 1759. Astley was an equestrian, circus owner, and inventor, who is generally regarded as the father of the modern circus. It may be that Davenport's interest in the circus was due to his apparent physical dexterity and athleticism. It is claimed he had no difficulty in jumping a five-bar gate, and once ran around the high battlements of a church.

The Old Crown in Wigston, haunt of the notorious highwayman George Davenport.

On another occasion while drinking in the Bull's Head in Belgrave, Davenport overhead a conversation at the bar about the best ways of apprehending him and thus claiming a substantial reward. After finishing his drink, Davenport identified himself and challenged the men to 'catch me if you can'. He then sprinted out of the pub, down the garden and jumped the wall, leaving the drinkers far behind.

He was the fear and the curse of travellers in and around Leicester for eighteen years, robbing the rich and giving the proceeds to the poor. Entering pubs such as the Old Crown, he would force the wealthiest customer to buy a drink for everyone in the bar and then take away any remaining money the poor man might have had about his person, but he was finally caught and sentenced. He was hanged at Red Hill near Belgrave in 1797, and may well have drunk his last pint at the Talbot Inn where many a convicted man stopped on his way to the gallows.

The pub is said to be one of the most haunted places in Wigston. A woman roams the bar and is often seen by customers, and a man is also sometimes heard down in the cellar.

Chapter Four

Out in the County

44. The Belper Arms, Newton Burgoland

The original building is said to date back to 1290 and even the later extension looks suitably old, which gives The Belper Arms justification for claiming to be the oldest pub in Leicestershire. It is thought to have been built to provide accommodation for the men who worked on the construction of the nearby parish church. In the past it was called the Shepherd & Shepherdess and it has also been known locally as the Halfway House. It is certainly about halfway between several of the villages in north-west Leicestershire including Snarestone and Heather, Shackerstone and Swepstone.

The pub has one famous resident who has become known as Five-to-Four Fred. He is a ghost who makes his presence felt at precisely 3.55 a.m. or 3.55 p.m. Some local historians have identified him as a highwayman who was courting a serving girl from

The Belper Arms in Newton Burgoland.

The Belper Arms, allegedly home of 'Five to Four Fred'.

The Belper Arms, the building is said to date to the thirteenth century.

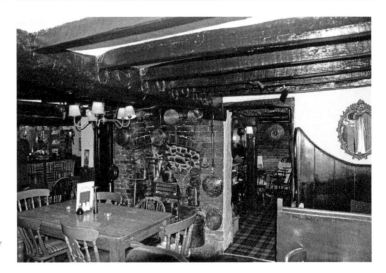

One of the oak beams in The Belper Arms is said to have come from a nearby tree previously used for hangings.

The Belper Arms where customers wait until 3.55 p.m. for a ghostly experience.

the pub and who was murdered by a jealous rival. The theory is that he still roams the building, looking for his girlfriend and the man who murdered her. This would explain the sort of sensations that many who work in and visit the pub have reported. Men and women have different experiences: women have felt their cheeks and face being stroked, or are rather unceremoniously patted or slapped, but men feel a sensation of having hands placed over the nose and mouth as though they are being deliberately suffocated.

There have been no 'sightings' of Five-to-Four Fred because he has only been felt. In 1972, television reporter the late Gwyn Richards visited the pub for ATV, the independent television company based in Birmingham to report on the numerous reports of paranormal happenings. Although his report plays to the sexism of that time, the interviews to camera from the women who describe their experiences are genuinely unnerving because of their natural and disarming recall. Since his death in 2008 it has been revealed that Richards was an historical researcher of fine standing, and his reputation would suggest that his television piece represented good investigative journalism.

More than forty years later, the manifestations are still present and are unnervingly similar to those in the ATV report. Several mediums have investigated the reports which include an account by the current landlady:

> He always makes my ears ring and he has touched my hair. I've never seen him though, and I don't think we are in any danger. He has been here longer than we have.

Fred is most active in the oldest part of the building. Two visiting mediums have agreed that he wears a leather cape or an oil skin. A ghostly boy of around fourteen and a young girl of around nine years old covered in red blotches have also been seen, who run past the highwayman, and appear to be from a different period in the building's long history.

One theory about the sense of suffocation is the shape and configuration of the wooden beam above the bar which may be from a nearby tree that was used for hangings. According to structural engineers, the beam serves no useful purpose in supporting the building, so it must have been placed in the pub for another reason.

The pub was fully refurbished in 2014 at a cost of over £150,000, but fortunately the period atmosphere with its oak beams, a display of English copper and brass work and open fires has been retained. The dining room is decorated in the style of a library of a country house with artefacts and photographs telling the story of the building, displayed on the walls.

45. The (New) Red House, Coalville

In 1832, the third oldest railway line in the world opened in Leicestershire, connecting the city of Leicester with the rich coal seams that lay to the north-west of the county. Thirteen miles from Leicester along this railway line was an area of open countryside and scrubland which featured nothing other than the convergence of two lanes. One of these lanes, running north–south linked the villages of Whitwick and Hugglescote, the other, running east–west connected two turnpike routes, Bardon and Hoo Ash. The former route was known as Long Lane, and was destined to form the main street along which the new mining town of Coalville would be developed. Where these two routes converged a dignified coaching inn was built, which is now known as the Red House.

The Red House probably dates to the seventeenth century whereas the town of Coalville (named after Coalville House, the residence of the owner of

The Red House, the oldest building in the centre of nineteenth-century Coalville.

Whitwick Colliery) is much later and after the arrival of the railway, but the pub is now at the very centre of the town, adjacent to the tall solid war clock tower war memorial. After the decline of the coal industry in the area, Coalville faced a period of economic decline, but today it is a very busy town, with the Red House at its heart.

It is interesting that the earlier isolation of the building gave it an important additional purpose in many peoples' lives. The lanes marked the boundaries of no less than six parishes in what was an area of wasteland, and the Red House was brought into use as a reference for the area. Even in the surrounding counties such as Derbyshire and Nottinghamshire, the location of the Red House was known, and so the birthplace or former residence of anyone describing themselves or their family as being 'of the Red House' could be immediately defined.

As with many old buildings, local tales of bad deeds abound. In this case, the pub was also once known as the Cradle & Coffin. The accompanying story tells of a landlord whose wife was unfaithful and had a child by another man. The landlord murdered his wife and the young child, burying them both beneath the grounds of the pub.

There seems to be very few explanations for the name of the pub. It could have course have been red, but before the industrial revolution reached this area, the buildings were mainly constructed of quarried stone or were wooden-framed with mud bricks and thatch. It does not seem likely that it was painted red. Lacking any other viable explanation, one possibility is that the area was originally wet land which encouraged reed beds. The building could have marked the crossing point of raised pathways through the reed beds and may therefore have become known as the Reed House. The annual cycle of growth and die-back means that plant material is composted which in time provides a suitable habitat for grasses and scrub to grow. This landscape certainly fits the description of the area prior to the development of the town, and even today there are ponds and marshland in the area behind the pub.

46. The Cow & Plough, Stoughton Park, Oadby

One of the five food pubs belonging to the enterprising Steamin' Billy Brewing Co. Ltd, and this time the location is a farmhouse on one of the former estates on the outskirts of Leicester described as 'old and rambling'.

The setting is what is left of Stoughton Grange Farm on the Powys-Keck estate which had a history dating back to the time of Edward the Confessor. Harry Leycester Powys-Keck was the last member of his family to live at the Grange which occupied part of the present farm site. It was put up for sale in 1913 but not sold. In 1919, the entire estate was bought by the Co-operative Wholesale Society, and the grange was demolished in about 1925. The estate then became the centre for the Co-op's dairy-farming in Leicestershire. Granges were agricultural outposts of abbeys, and this grange was associated with Leicester Abbey.

In 1820 three small Gothic-styled lodges were added by the side of the road from Evington to the Gartree Road. These have survived and bear the arms of the Keck family and can be seen on the approach to the Cow & Plough.

In the 1990s, the Co-op converted the farm buildings as part of a new project called Farmworld where families could visit the countryside and watch a 'real' farm

The Cow & Plough, occupying former farm buildings at Stoughton Park, Oadby.

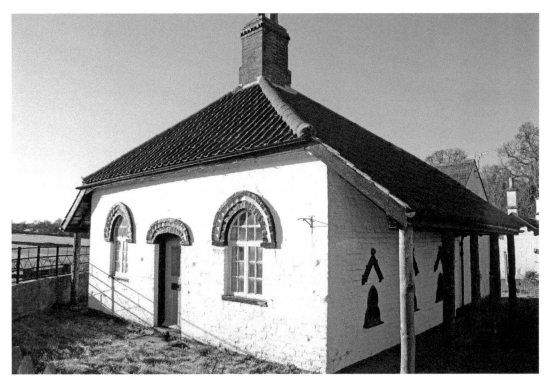

One of the Gothic-styled lodges at the Stoughton Farm estate.

in operation, but this closed as a precautionary measure during the foot-and-mouth disease outbreak in 2001 and never reopened. The Co-op still uses the farm, but gradually converted the buildings nearest the road access into a small business park.

At last, the arrival of the Steamin' Billy Brewing Co. Ltd has heralded perhaps a new and positive chapter in this long story. Its former history and heritage is being recognised once again and new branding is ensuring that the land retains its agricultural atmosphere. There has always been a close relationship between the brewing of beer and the working of the land for food.

47. The Tin Hat, Trent Road, Hinckley

Here is a modern pub on a modern housing estate which is named after an old artefact from Hinckley's past; as is often the case with folklore, there are several different versions of the story.

It is said that a travelling sheep drover boasted that he could drink a hat full of ale. A Hinckley landlord chose to test the man's claims and commissioned the local blacksmith to make a large tin hat which could hold up to thirty-four pints of beer. How the drover fared after attempting to demonstrate the validity of his claim is not recorded.

Another version of the story relates to a bare-knuckle fight which was staged at the Harrow Inn on the Watling Street near Hinckley. Some spectators on the way home stopped off for a (further) drink at the Crown Inn in Hinckley and commented that 'they put hats on their pumps in Hinckley'. They had seen a tin bucket which had been placed upside-down on top of a pump. There is a theory that it was a local custom in

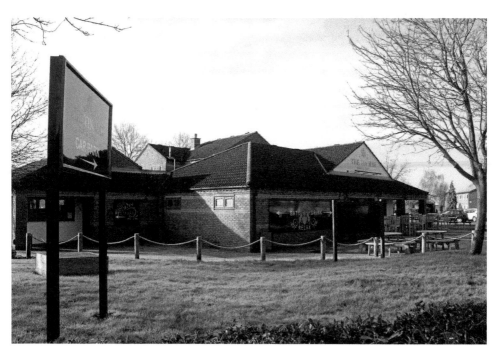

The Tin Hat – a modern pub on Hinckley's Hollycroft Estate.

The original tin hat, rescued by the *Hinckley Times* and now in the town's museum.

the area to place buckets on water pumps to keep them clean and thus prevent the spread of disease. Hinckley was for many years colloquially referred to as 'Tin 'At'.

A further version of this strange tale tells of the landlord of the Crown Inn, who also ran a drinking booth at the races in Leicester, hanging a large tin hat on top of a pole as an advertisement. This particular 'hat' was later sold to the landlord of the Three Cranes in Leicester's Humberstone Gate, and was returned to Hinckley in 1972 when it was bought by the *Hinckley Times* newspaper for ten guineas. It is now on display in Hinckley Museum. The story lives on with a number of businesses in the town still using a tin hat as a logo or motif, and in the theatrical group, The Tin Hatters, who perform at Hinckley's Concordia Theatre.

48. The Anne of Cleves, Burton Street, Melton Mowbray

As its name suggests, the history of this pub, a Grade II listed building today, is bound up with the fortunes of the Church and of a number of high-profile individuals during the tumultuous reign of Henry VIII.

It was built to provide accommodation for priests connected with the nearby Parish Church of St Mary. Artefacts including a roof tile and some pottery fragments which were found during refurbishment work in 1996 confirms that the original structure dates to at least the fourteenth century and possibly earlier. An archaeological report in 2011 proposed a construction date of 1384.

During the fifteenth century it was occupied by chantry priests who were paid to say prayers for the departed. St Mary's parish had no less than fourteen chantries (the places where these prayers were said). Henry VIII acted against the religious houses of England and their traditions. At the Dissolution of the Monasteries, religious buildings became his property, and the king gave this house to his chancellor, Thomas Cromwell.

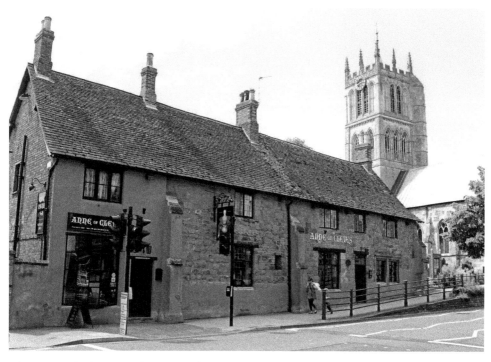

The Anne of Cleves, Melton Mowbray.

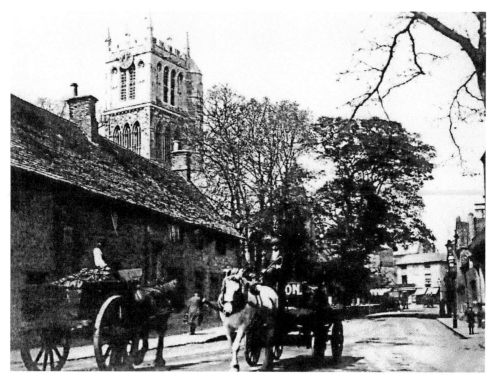

The Anne of Cleves, built to accommodate chantry priests at St Mary's Parish Church.

His ownership was brief. Cromwell may have lived here for a time in 1540, but in the following year, after proposing that Anne of Cleves became Henry's fourth wife following the death of Jane Seymour, Cromwell fell from favour. The marriage failed almost before it had begun. His estates were confiscated, and in 1541, only two years after he had acquired the Cleves House, he was executed.

Having been wife to Henry for just six months, Anne of Cleves agreed to a divorce, and as part of the settlement, the king granted her a number of properties including this old priests' house. Henry may have visited Melton to view the property at about this time, but there is no evidence that Anne ever came to the building that still bears her name.

After these dramatic events, the building was used as accommodation for the vicar of Melton and then, when a new vicarage was built in 1760, became a private house. In the nineteenth century, part of the house was demolished, and by the 1930s it had been converted into a café. It became a public house in 1995.

49. The Three Swans, High Street, Market Harborough

This coaching inn, which dates to the early years of the sixteenth century, will be forever associated with its most famous owner and landlord, John Fothergill who took over the premises in 1934. Fothergill was also a writer and author, and his colourful and forthright comments about the pub and the town of Market Harborough makes for fascinating reading in the twenty-first century.

It was originally known as The Sign of the Swanne. There are indications that the present wrought-iron inn sign, depicting three swans in silhouette, although old, has

The famous late seventeenth-century
Three Swans sign.

The famous portrait of the infamous landlord, John Fothergill.

The Three Swans in Market Harborough's High Street.

High Street, Market Harborough by Leicester artist George Henton (1861–1924).

been re-engineered so that two of the three swans are newer. Of the many interesting and famous people who have passed through its doors is Charles I, who lodged here on the night before the battle of Naseby on 13 June 1645, and Queen Anne, who as Princess of Denmark, visited Market Harborough in 1688 and was accommodated along with her sizeable entourage which included the Bishop of London and the Earl of Dorset.

When Fothergill arrived in Market Harborough he was not impressed by either the town or the hotel. He called it 'the foulest little pub possible with dirty sheets', and continued at length:

> Inside the inn, whatever the dirt, not always apparent, the awful furniture, beds, the rat-holes, the wall papers coming away from the walls, the tiny, unventilated lavatory on the first floor, used by the entire house, the bars and people of the town, and the strange stillness throughout, for no one seems to come in, you could see at once, the building had a loveable character.

He was less than enthusiastic about the remainder of Market Harborough, noting that:

> Most of the town wants paint and those who do paint want ideas. The big sundial on the church tower is peeling away.

He wrote that the graceful curve of the road which passed the front of the Three Swans led visitors to anticipate a more interesting view around the corner, but the only satisfying vista was the one that could be seen as you left the town in the direction of Leicester.

There are many stories of hauntings and ghostly encounters at the Three Swans. Most seem to be related, not surprisingly, to John Fothergill or to a portrait of him. It is said that after his death, Fothergill's widow removed the portrait from the bar and put it in the cellar. The next day, heavy rain led to flooding, but the rising waters stopped just short of the portrait. It is also claimed that mishaps (and even premature death) occurs to anyone who moves or even touches the portrait. It was reported that on one occasion when the portrait was taken down, all the computers in the building crashed, and on other occasions, paint turned from blue to green, and the electricity supply failed. Even as recently as October 2013, the current owners of the Three Swans, during a planned redecoration of the bar which is named after Fothergill, decided to work round the portrait and leave it in place.

The pub retains not only its more recent traditions but also the architecture of its past times as a coaching inn, one of an ensemble located in the Market Place and High Street serving this very busy route on the main route towards London to the south and to Leicester and thence the north of England. The former stabling areas are now converted into modern reception and conference facilities.

There is a fine and comprehensive photographic record of Market Harborough as several early professional photographers were based in the town; but one of the finest images of the Three Swans and the road north towards Leicester is by the Leicester photographer and artist George Moore Henton. Meticulous in detailing each of his photographs, Henton notes that his photograph was taken on 17 April 1913.

50. The Windmill, No. 62 Sparrow Hill, Loughborough

In this context, 'sparrow' means 'little', the word being employed in the same way as 'fledgling' is sometimes used to describe something new and yet to be tested, such as a 'fledgling idea'. The hill leads to All Saints and Holy Trinity, the Parish Church, and in the shadow of the church is this ancient hostelry. Many inns which are found in proximity to early parish churches were originally built to provide accommodation for labourers working on the building or rebuilding of the church, and were then converted into other uses, sometimes in connection with the church but also as taverns. However, it is just as likely that the Windmill was once a farmhouse, or farm buildings.

Loughborough has several very old inns, and it may be difficult to prove the claims of the Windmill that it is the oldest in the town, but its location in the earliest part of the settlement is in its favour. The history and heritage of this quiet area is reflected in the Grade II listed status of the pub and the fact that it is in the Church Gate Conservation Area. It was certainly trading in 1625 when there is documentary evidence, and it is likely that some of the fabric of the building is as early as the sixteenth century, although the exterior is mostly from the 1800s. The cruck-frame timbers within the pub is certainly fifteenth century, and has evidence of carpenters' marks.

The only evidence of a windmill comes from the historian and traveller John Throsby who made an engraving of the church and included a windmill. Throsby was born in Leicester in 1740, and much of his extensive antiquarian work on Leicestershire was incorporated into John Nichols' massive eight-volume *History and Antiquities of the County of Leicester* which was completed in 1815, including this view of Loughborough. Although very stylised, it is possible that the engraving shows the buildings either side of Sparrow Hill rising up to the church.

In more recent times, the pub has been a meeting place for an eclectic range of local groups which have included the Royal Antediluvian Order of Buffaloes and the United Order of Druids.

A terrace and shop in Sparrow Hill in the late nineteenth century.

The windmill and church in an engraving from *c.* 1815.

51. The Coach & Horses, Leicester Road, Kibworth Beauchamp

In the heyday of the stage coaches there was an abundance of inns along the turnpike route through Kibworth Harcourt including the Three Horseshoes (now Bobolis Restaurant), the Admiral Nelson and the Rose & Crown. The Horseshoes was the most popular with up to twenty-four coaches stopping every day. The last inn on the road before heading south to the next town, Market Harborough, was the Coach & Horses, but no doubt its trade picked up considerably in 1815 when a new route bypassed the very sharp corners of the village and left all but Rose & Crown and the Coach & Horses isolated from the busy route.

For many years, a stone horse trough was situated outside the pub by the roadside. Local histories recall that it was conveniently placed for 'dunking' any of the village lads who had imbibed one drink too many, in order to sober him up. The trough is now in the care of the Leicester Museum Service at the Newarke Houses Museum.

Situated close to the parish boundaries between Kibworth Beauchamp and Kibworth Harcourt, the Coach and Horses became a convenient headquarters for the Kibworth Dig in 2010 which was an important part of television historian Michael Wood's ground-breaking six-part series *Story of England*. Several hundred local people dug fifty archaeological test pits and brought their finds to the pub after a busy weekend of research and filming. The then landlord of the pub took part, using a mechanical excavator to break through the tarmac of the car park, later to discover one of the most remarkable artefacts of the entire project.

In 2015, the pub narrowly avoided serious damage when a fire broke out, and this was followed by flooding due to a burst water main. Now, with a change of management and having been redecorated throughout, this delightful old building is again looking smart and welcoming. The author is particularly pleased to see its renaissance as one of his ancestors owned the pub.

The Coach & Horses,
Kibworth Beauchamp.

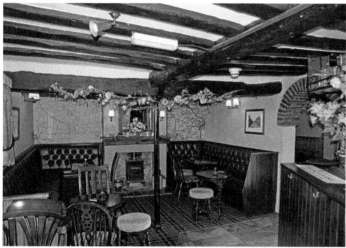

Recent redecoration has
retained the Coach &
Horses' atmosphere.

A romantic impression
of the coaching age in
Kibworth.

List of Pubs

1. The Globe — No. 43 Silver Street, Leicester, LE1 5EU
2. The Corn Exchange — Market Place South, Leicester, LE1 5GG
3. The Friary — No. 12 Hotel Street, Leicester, LE1 5AW
4. The Molly O'Grady — No. 14 Hotel Street, City Centre, Leicester, LE1 5AW
5. The Market Tavern — Market Place South, Leicester, LE1 5GG
6. O'Neills — Nos 16–20 Loseby Lane, Leicester, LE1 5DR
7. Firebug — No. 1 Millstone Lane, Leicester, LE1 5JN
8. Rutland & Derby Arms — No. 21 Millstone Lane, Leicester, LE1 5JN
9. The Criterion Free House — No. 44 Millstone Lane, Leicester, LE1 5JN
10. The Fountain — No. 52 Humberstone Gate, Leicester, LE1 3PJ
11. The Queen of Bradgate — No. 97 High Street, Leicester, LE1 5YP
12. The Orange Tree — No. 99 High Street, Leicester, LE1 4JP
13. The Highcross — Nos 103–105 High Street, Leicester, LE1 4JB
14. The Cosy Club — No. 68 Highcross Street, Leicester, LE1 4NN
15. The King Richard III — No. 70 Highcross Street, Leicester, LE1 4NN
16. The Exchange — No. 50 Cultural Quarter, Leicester, LE1 1RD
17. The King's Head — No. 36 King Street, Leicester, LE1 6RL
18. The Charlotte — No. 8 Oxford Street, Leicester, LE1 5XZ
19. The Bowling Green — No. 44 Oxford Street, Leicester, LE1 5XW
20. The Sir Robert Peel — No. 50 Jarrom Street, Leicester, LE2 7DD
21. The Salmon Inn — No. 19 Butt Close Lane, Leicester, LE1 4QA
22. The Musician — No. 42 Crafton Street West, Leicester, LE1 2DE
23. Bridle Lane Tavern — No. 2 Junction Road, Leicester, LE1 2HS
24. The Parcel Yard — No. 48A London Road, Leicester, LE2 0QB
25. Marquis of Wellington — No. 139 London Road, Leicester, LE2 1EF
26. The Old Horse — No. 198 London Road, Leicester, LE2 1NE
27. The Clarendon — West Avenue, Leicester, LE2 1TS
28. The Font — No. 52 Gateway Street, Leicester, LE2 7DP
29. The Black Horse — No. 1 Foxon Street, Braunstone Gate, Leicester, LE3 5LT
30. The Counting House — No. 40 Almond Road, Leicester, LE2 7LH

31. The Western No. 70 Western Road, Leicester, LE3 0GA
32. Bar 66 No. 66 Braunstone Gate, Leicester, LE3 5YA
33. The Cradock Arms No. 201 Knighton Road, Leicester, LE2 3TT
34. The Black Dog No. 23 London Road, Oadby, Leicester, LE2 5DL
35. Glen Parva Manor The Ford, Glen Parva, Leicester, LE2 9TL
36. Grange Farm Glen Road, Oadby, Leicester, LE2 4RH
37. The Cricketers Grace Road, Leicester, LE2 8AD
38. The Real Ale Classroom No. 22 Allandale Road, Leicester, LE2 2DA
39. The Tom Hoskins No. 131 Beaumanor Road, Leicester, LE4 5QE
40. The Talbot Inn No. 4 Thurcaston Road, Leicester, LE4 5PF
41. The Cedars Main Street, Evington, Leicester, LE5 6DN
42. The Old Baker's Arms The Green, Blaby, Leicester, LE8 4FQ
43. The Old Crown Inn No. 46 Moat Street, Wigston, Leicester, LE18 2GD
44. The Belper Arms Main Street, Newton Burgoland, Coalville, Leicestershire, LE67 2SE
45. The Red House No. 1 High Street, Coalville, Leicester, LE67 3EA
46. The Cow & Plough Gartree Road, Oadby, Leicester, LE2 2FB
47. The Tin Hat No. 45 Trent Road, Hinckley, Leicester, LE10 0YA
48. The Anne of Cleves No. 12 Burton Street, Melton Mowbray, Leicester, LE13 1AE
49. The Three Swans High Street, Market Harborough, Leicestershire, LE16 7NJ
50. The Windmill No. 62 Sparrow Hill, Loughborough, Leicestershire, LE11 1BU
51. The Coach & Horses No. 2 Leicester Road, Kibworth Beauchamp, LE8 0NN